OF

Agano & Takatori

FAMOUS CERAMICS OF JAPAN 2

Agano & Takatori

Gen Kōzuru

KODANSHA INTERNATIONAL LTD.
Tokyo, New York, San Francisco

distributed in the United States by Kodansha International/USA, Ltd.,
through Harper & Row, Publishers, Inc., 10 East 53rd Street,
New York, New York 10022

published by Kodansha International Ltd., 12–21 Otowa 2-chome,
Bunkyo-ku, Tokyo 112 and Kodansha International/USA, Ltd., 10 East
53rd Street, New York, New York 10022 and 44 Montgomery Street,
San Francisco, California 94104

LCC 80–84463
ISBN 0–87011–454–9
JBC 1072–789448–2361

Agano and Takatori Wares

AGANO WARE

The Hosokawa clan was an aristocratic family of distinguished standing after the Muromachi period (1392–1573); a Hosokawa successively served the warlords Oda Nobunaga, Toyotomi Hideyoshi, and Tokugawa Ieyasu and held influential positions under them. One of these, Hosokawa Tadaoki, was thirty-seven years old when he was promoted from the position of Lord of Tango (a fief in present-day Hyōgo Prefecture) to that of Lord of Buzen, in Kyushu, in recognition of his meritorious services in the Battle of Sekigahara (1600).

Tadaoki's wife, Otama, was a daughter of Nobunaga's general and assassin Akechi Mitsuhide. She was a Christian and is more generally known in Japanese history by her Christian name, Gracia. She died before the Battle of Sekigahara, a victim of intrigue and the involved politics of the times. Tadaoki, however, never remarried, and it may be that he expressed his devotion to her in his passion for ceramic art.

Tadaoki's father, Hosokawa Yūsai, was an outstanding man of culture during the period of the Japanese Civil Wars (1482–1558), and Tadaoki himself was well versed in *waka* poetry, painting, and the Nō theater. He also studied under the great tea master Sen no Rikyū and is said to have been one of Rikyū's most illustrious pupils. However, unlike many other warlords who became aficionados of the tea ceremony at that time, Tadaoki never forgot that he was first and foremost a samurai warrior. Consequently, he used to wear his sword even during the tea ceremony ritual, despite the rule against weapons being taken into the tea room. In his opinion, a warrior should always be prepared to do his duty and fight. Called the perfect counterpart of Nobunaga, he was a remarkable man, appreciator of the fine arts, who was master of the sword and pen alike. It was under the leadership of this same

Tadaoki that the production of Agano ware began.

Agano ware was first fired by a Korean potter known as Sonkai (Chonhai in Korean), who came over to Japan following Hideyoshi's invasions of Korea between 1592 and 1598. According to the *Honchō tōki kōshō* ("Historical Study of Japanese Ceramics"), Sonkai first came to Karatsu, in Hizen Province, in 1592, but then went back to Korea before returning to Japan, this time in the company of Hosokawa Sansai from Buzen Province. There he became a retainer of the Hosokawa clan and was engaged to make pottery at Agano Village, Tagawa County, in the same province. It was from this village that he took his Japanese name, Agano Kizō Takakuni. As a result of the clan's policy of encouraging industry, Sonkai was provided with seventy retainers to help with production, and a decree was issued forbidding the use of any pottery other than Agano wares within the clan's domain.

The *Agano-yaki yurai-sho* ("Origin and History of Agano Ware") states that Sonkai's ancestors were a celebrated family during the Ming dynasty, and that he was thus a descendant of a high-standing family in China. This is not substantiated by material proof, but the Agano kiln sites have yielded dishes with iron oxide brush designs that are believed to be Xsi-cun ware from Guangdong Province. Further evidence of Chinese influences has been found in shards, dishes, hanging flower vases, and teabowls with a bluish-green glaze poured over an opaque white straw-ash glaze—all of these from Shi-wan Yao, Fo-Shan City, in Guangdong Province.

Agano Ware: Early Period

Hosokawa Tadaoki came from Nakatsu to Kokura upon completion of Kokura Castle in November 1602, and it is there that he had the Saienba kiln built for what is known as "courtyard ware" (*oniwa-yaki*) production. The kiln was built by Sonkai upon Tadaoki's orders, and was fired under the guidance

of Tadaoki as tea master, and of his father Yūsai, also a distinguished tea master who was living in Kyoto at the time. It was a kind of "dilettante kiln" (*otanoshimi-gama*) for the Hosokawa lords, its wares being produced within the grounds of the castle and limited to use at tea ceremony occasions or presented as gifts to the shogun by the Hosokawa clan. There are no detailed records of this *oniwa-yaki*, and very few specimens from the kiln survive to this day, because it was only fired for two or three years following Tadaoki's arrival in Kokura. Indeed, the kiln site itself has not yet been identified, for Saienba has now been swallowed up by the burgeoning city of Kita-Kyushu. It is thought to be located near the north side of the Itōzu Hachiman Shrine, which abuts the business center of Kokura, but the area is too crowded for excavations of the site to be made.

One of the rare pots that has come down intact to this day is the teabowl known as "Kokura-yaki" (Plate 7). Both in its coarse wood-ash glaze and in its serving bowl style, it is a typical piece of old Agano pottery.

The obvious question is why should the Saienba kiln, which was so conveniently located in the town of Kokura, have fallen into disuse after only two or three years and have been transferred to Agano Village in Tagawa County? Various reasons may be considered in answer to this question, but the most likely one would appear to be that rich resources of good quality clay, wood fuel supplies, and feldspar for glazes were discovered in and around Agano. It was probably seen to be more convenient to have the clan kiln close to such raw materials.

Agano Village
Agano Village is situated in what used to be known as Buzen Province, now Akaike Town, Tagawa County, Fukuoka Prefecture. From very earliest times the area has been imbued with a sense of spirituality, for here is the holy mountain of Fukuchi-yama, and the Fukuchi-yama Gongen Shrine is in Agano. It is from this shrine that the ascent of Mt. Fukuchi is made, on the Tagawa side of the mountain. Less than one kilometer east of Kōzuru, near the entrance of Sarayama pottery village, is the Temmokuzan Kōkoku-ji, a temple of the Sōtō sect of Zen Buddhism.

Mt. Fukuchi rises to a height of about 900 meters above sea level and spans what used to be the border between the two provinces of Buzen, run by the Hosokawa clan, and Chikuzen, under the control of the Kuroda clan. To the west of Mt. Fukuchi's ridge lies Mt. Takatori (alt. 630 meters), and nearby may be found the Takatori ware Takuma kiln.

When one looks at the overlapping mountain folds of Fukuchi and Takatori with Fukuchi at the front and the river Hikosan flowing this side, one can see stretching from right to left the three kiln sites of Iwaya Kōrai, Kamanokuchi, and Sarayama Hongama, one in each valley. These three old workshops are collectively called the Agano Koyō (Agano Old Workshops). Farther west, in the province of Chikuzen at the foot of Mt. Takatori are two other kiln sites—Takuma and Uchigaiso. Thus all five kilns are located in an approximately straight line— probably because the clay stratum from which each takes its ball clay runs in a straight line along the mountain.

This area is more generally known as the Chikuhō (Chikuzen-Buzen) coalfield, but parallel with the coal existed a clay stratum suitable for making pottery. The nature of the clay was not, however, uniform. This meant that different areas yielded different qualities of clay. One type, known as Ikata clay, was used for making medium-sized and small bowls for powdered tea. Another type, Natsuyoshi clay, was used for making *sencha* leaf teabowls and small, single-spray flower vases. A third type, Ichiba clay, was used for making large bowls and water jars, while a fourth type, known as Sasao clay, was used for making tea ceremony water containers, *mizu-koboshi* water jars, and flower vases (see *Manman hikae* record of the late Edo period).

These rich varieties of pottery clay were not, however, discovered during the thirty years that the Hosokawa clan ruled the province of Buzen, but after the Hosokawas had taken up their new position as feudal lords of Higo Province. The Agano area was then placed under the jurisdiction of its new ruler, Ogasawara Tadamasa, and the Ogasawaras ruled over the province for 240 years, until the abolition of the feudal fiefs and the new administrative system of prefectures was established in 1871. It was during this period that the various techniques were developed in accordance with these varying types of clay.

The Kamanokuchi Kiln

There are reasons to believe that the first ceramic workshop of Agano ware that went into full-scale production was the Kamanokuchi kiln. This kiln site exists less than one kilometer uphill from the Kōkoku-ji temple on the slopes of Mt. Fukuchi, and its remains may still be seen in the dark shade of a bamboo grove there. It is a pretty large climbing kiln, with fifteen stepped chambers three meters in width and forty-one meters in length overall. Not a single fire brick was used in the building of this kiln. Instead, as was customary in those days, the kiln was constructed with clay and silica sand only.

Shards unearthed from the kiln site, and pieces that have survived to this day, show that pots were made with low foot rims and thin-walled bellies rising from the foot rims. These Kamanokuchi kiln fired pots clearly reveal the influence of Tadaoki's tea ceremony taste. They include some of the finest pieces made during the 370-year history of Agano pottery. Wares include not just brush painted, incised, or calligraphic designs on cylindrical tea-bowls (e-Agano, ji-Agano, hori-Agano, kakewake, etc.), but a large number of wood-ash glazed tea-bowls. Shards that have been unearthed show a range of almost every conceivable type of tea caddy: e.g., iron glazed katatsuki (with angular shoulders), mimi-tsuki (with ears), bunrin (apple shaped), taikai (large and wide mouthed), minakuchi (wide mouthed and round bottomed), etc. Water containers include a square-handled type with white rice-straw-ash glaze suffused with a green glaze (Plate 11); another type with handles was covered with an ash glaze (Plate 9); yet another with combed decoration was covered with a wood-ash glaze, and so on. These unearthed shards show that most pots had a straight-sided mouth, without a flared, everted, or inward-closing lip. In view of the fact that most pieces were made for tea ceremony use, it is perhaps surprising to find that they reveal little experimentation on the part of the potters. The foot rims are rarely given a "crescent moon" shape (mikazuki kōdai), but are predominantly in a regular, round form, clearly defined and dignified.

For some time I thought that this odd fact probably resulted from the character of those who gave advice to the potters about their work. However, I recently excavated a rather strangely shaped pottery object that turned out to be the ring for supporting the pivot (shimbō-uke) of a potter's wheel. This pivot ring was set at the joint of the wheel head and the spindle, and helped keep the wheel rotation smooth and stable, thereby resulting in a regular, circular foot rim when the potter trimmed his pot. It is probably for this technical, rather than purely aesthetic, reason that pots were made with round foot rims at the Kamanokuchi workshop.

Apart from tea ceremony wares, functional pots for everyday use were also made in the pottery. These included pouring bowls, kneading bowls, and water jars with handles. The better-made pots are glazed all over, without the clay body being exposed anywhere. Coarser wares are made of a rough, gritty clay, and are crude in workmanship. Only the upper part of the pot is glazed, so that the clay texture is revealed at the foot rim.

Those teabowls with the "crescent moon" foot rim that are very rarely found, together with paddled, lidded jars and white and amber glazed saké bottles, are hard to distinguish from those made at Karatsu. Straw ash, amber, and iron glazes are used; however, the coarse wood-ash glaze with a faint celadon tinge is not seen on other wares of that period.

The foot rims show traces of shell fragments in their composition. It is interesting to note here that the shijimi (Corbicula), a freshwater mussel obtainable from mountain streams, was used at Kamanokuchi, which is located deep in the mountains, while the akagai (a cockle) seashell was used after the potters moved to Yatsushiro in Higo Province.

In its record of "the ceramic manufacture mountain of Agano village," the census register of Tagawa County, Buzen, mentions the existence in 1622 of peddlers and pack horses in addition to that of twenty-two households of potters. This would appear to suggest that the official clan kiln at Kamanokuchi also made wares for sale to local people. The reason for such thriving activity probably stems from the fact that many of the potters at the Takatori kiln of Uchigaiso uprooted and came to Kamanokuchi after their own workshop incurred the displeasure of their feudal lord. The vitality of Kamanokuchi at this time may be seen in the fact that the climbing kiln had further chambers added to it two or three times (as an examination of the kiln site will show). This influx of potters led to the birth of a new kiln, the

Agano Sarayama Hongama, *hongama* meaning "main kiln."

But potters coming from Takatori also brought with them various Takatori techniques, such as stamped floral designs, overglaze techniques, incised ornamentation such as sgraffito, and iron brush painting. To some extent, these new techniques threatened the Agano traditional style, but under an able leader, the Kamanokuchi kiln produced especially fine Agano pieces (see Plate 6) during its last ten years.

The Iwaya Kōrai Kiln

The Iwaya Kōrai kiln is located between Agano and Benjō Iwaya in the town of Hōjō, Tagawa County. It appears that the kiln here was first fired around 1605, at almost the same time as the Kamanokuchi kiln was being operated, but it was probably closed down around 1632 when the Hosokawa lord, Tadatoshi, took up his new position as ruler of Higo Province. Certainly, no mention is made of the kiln in the 1694 publication the *Buzen kikō* ("Accounts of a Journey through Buzen"), where the writer, Kaibara Ekiken, is concerned only to describe a large man-made cave in the neighborhood.

It used to be thought that both the Iwaya Kōrai kiln and the Kamanokuchi kiln were run by the Korean potter Sonkai. However, the study of shards unearthed there shows that both techniques and styles of pottery differed essentially from one kiln to the other. In particular, there is little evidence of the existence of techniques that one would have expected if Sonkai had been responsible for the wares produced at the Iwaya Kōrai kiln. One finds, instead, north Korean techniques such as thick walls in forming, a matt white straw-ash glaze, and so on, and these show close resemblance to wares made in Hoeryŏng and Myŏngch'ŏn. This would suggest that Korean potters did not come to Agano all at once, but that different groups came from different parts of the country at various stages during Hideyoshi's invasions of Korea. While Sonkai set up one kiln at Kamanokuchi, another group of potters built a different kiln at Iwaya Kōrai. The former was fortunate in being officially patronized by the Hosokawas. The latter, however, did not attain such status and remained a privately run workshop.

In fact, however, the Iwaya kiln contributed much to the clan's coffers. Because of the closing down of the Takatori ware Uchigaiso kiln in 1624, a considerable number of potters went to work at Iwaya. They, too, were of north Korean origin, and this served to strengthen the already north Korean character of the kiln. Being a private enterprise, the workshop was not run under strict supervision, and it could make use of and freely experiment with various techniques. There were potters of both excellent and somewhat inferior technical ability, so that the quality of the kiln's products is diverse and rather crude in comparison with that of the official Kamanokuchi workshop ware. But precisely because of this, the Iwaya wares are all the more appealing, for they reflect the characters of the potters working at the kiln at this time.

Recent excavations have brought to light the fact that various tea ceremony wares were also made at Iwaya. One rarity is the discovery of a small piece of pottery that was used as a kind of Seger cone to measure the temperature of a kiln chamber during firing.

It is not clear what happened to the Iwaya potters, but it is likely that they followed their feudal lord after the Hosokawas were appointed to the administration of the province of Higo. This hypothesis is supported by the fact that old Shōdai pottery from Higo is known to have been started up immediately after the arrival of the Hosokawas in that part of Kyushu. It bears close resemblance to the Iwaya kiln wares in many respects, particularly in the way it is covered with an amber or white straw-ash glaze. However, because the ball clay used at Shōdai contains a high percentage of iron and is not very refractory, the pottery made there had to be thick walled in order to prevent wares from collapsing during firing. This makes the overall effect of Shōdai pottery somewhat on the dull side.

NEW AGANO PERIOD

Agano Sarayama Hongama

When the Takatori Uchigaiso kiln was closed down in 1624, its potters moved to the Kamanokuchi and Iwaya Kōrai workshops located across the mountain ridge in Agano. It seems that there were too many to be accepted at the two kilns already there, so a new kiln and workshop, known as the "main kiln" (*hongama*), were started in the following year.

The Hongama kiln is situated in what is now Agano Sarayama, Akaike Town, Tagawa County. The kiln site is located along the approach to the Middle Shrine of the Fukuchi Gongen Shinto complex. Shards unearthed around old ruined houses nearby show that pots were made with techniques closely resembling those of south Korean potters who had worked at the Kamanokuchi kiln in its early period. This suggests that the Sarayama Hongama kiln was established by potters from Kamanokuchi who handed over the running of their old kiln to the many immigrants from Uchigaiso and moved to a new site.

Seven years after the establishment of Sarayama Hongama, the Hosokawa lord, Tadatoshi, was reassigned to Higo. Sonkai accompanied him with his two oldest sons, Chūbei and Tōshirō, and set up a kiln at Yatsushiro in Higo Province. There he began producing Kōda wares (see "The History of Yatsushiro County"). He left behind his wife, his third son, Totoki Magozaemon, and his son-in-law Watari Kyūzaemon in Agano. Although Sonkai did not want to break up his family in this way, he had no alternative but to do so if both old and new masters were to be served. During the period of Ogasawara rule that followed in Agano, workmanship at the Hongama tended to lay stress on technical elaboration. The potters managed to gain better living and working conditions, and this seems to have adversely affected the vigorous style of early Agano wares.

The Ogasawara clan continued its administration of Agano ware production for fourteen generations, from the Sarayama Hongama period to the Meiji Restoration (1868). During this long period of peace and stability, society gradually settled down, a fact that is reflected in the quiet nature of Agano wares.

The production of teabowls, in particular, shows the way in which taste changed in Japanese society during the course of the Edo period (1603–1868). The tea ceremony had originally been practiced by warrior lords such as Oda Nobunaga and Toyotomi Hideyoshi. At this time, certain styles of tea wares were particularly favored—for instance, Sen no Rikyū's unassuming simplicity (*wabi*), Furuta Oribe's "lordly" style (*daimyō-cha*), and Kobori Enshū's elegance (*kirei wabi-cha*). After the death of Kobori Enshū, Kanamori Sōwa initiated an elegant court style (*kuge*) of tea ceremony instead of the earlier samurai oriented style. His ideas found favor with the court nobles who lived in Kyoto. One very famous potter was Ninsei, who originated the Omuro pottery near the Ninna-ji temple. He was one of Kanamori Sōwa's favorites and was patronized by many noble families, in particular the Kyōgokus, for whom he made special efforts and turned out one masterpiece after another.

Although Agano ware started out with a Korean continental style, in due course it, too, aimed to achieve the *kirei sabi* effect advocated by Kanamori and indulged in superficial decorative effects. This may have been an inevitable result of social influences, but the tenth Ogasawara lord, Katsumasa, encouraged the Hongama potter Totoki Magozaemon Hoshō to study both in Edo (modern Tokyo) and in Kyoto, the old capital. Hoshō absorbed the new ceramic style prevalent in Edo at that time before going on to study Raku ceramic techniques under the Kyoto potter Chūbei from 1804. The uniquely Japanese Raku ware, characterized by its low-fired, soft effects, had been developed in Kyoto from the end of the sixteenth century, and Hoshō was able to emulate these elegant wares once he got back to Agano. His prowess was rewarded by his clan lord, who gave him permission to ride on horseback through the streets and to be attended by servants—both privileges generally reserved for those of samurai class.

Raku influences on Agano ware can be seen in the use of a reddish purple glaze known as *shiso-de*, a "three-color" Agano glaze, an egg-yolk yellow glaze (*tamago-de*), and a "wood-grain" patterned effect known as *mokuzuri*, all of which began to be used from about this period. According to the *Manmandai hikae*, a bluish green copper glaze also was adopted in 1790. Various kinds of decorative techniques were developed, including inlay, bluish green suffusion, sprigging, incised and brushwork decoration. No other period during the history of Agano ware boasted such a variety of techniques, but the disadvantage of such plurality was that the techniques came to be seen as the be-all and end-all of production. Thus, eventually, towards the end of the Edo period, Agano ware lost all its original verve and vitality.

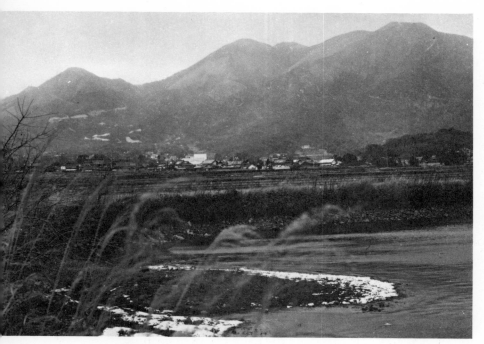

Fukuchi and Takatori mountains, around which Agano and Takatori wares originated.

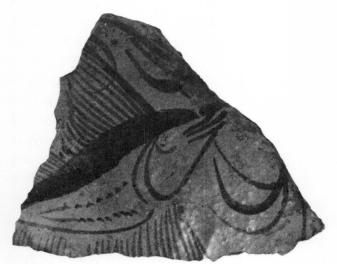

This shard unearthed ath the Kamanokuchi kiln site was probably brought from Guangdong Province of China.

Crescent moon foot rim (*mikazuki kōdai*)

TAKATORI WARE

The Jōbata Kiln

There are two accounts of the origin of Takatori ware. One, in "The Sequel to the History of Chikuzen Province," refers to Hideyoshi's invasions of Korea and tells how one of his generals, Katō Kiyomasa, brought back a Korean potter and set up a kiln in which he could fire porcelain in Higo Province. This potter he called by the Japanese name of Ido Shinkurō, and the pottery made by this Korean is known as Ido ware. Later on, he was invited to Chikuzen by the lord of that province, Kuroda Nagamasa, and had a kiln built for him in Takatori. It is from the name of this place that the ware takes its name. In a briefer account of this story, the "Record of the Takatori Household" mentions that Nagamasa told the potter to assume Takatori as his family name and Hachizō as his personal name.

It seems clear from these references that, like Agano wares, Takatori pottery owes its origins to the Korean Wars of 1592–98. Most kilns of this time were first built near the coast, and this is true of what is seen as the oldest Takatori kiln, *Jōbata-gama*. This Jōbata kiln is thought to have been established by Kuroda Nagamasa around 1601, soon after his transfer from Nakatsu in Buzen Province (Ōita Prefecture) to Fukuoka in the province of Chikuzen.

The majority of shards unearthed are parts of dishes; relatively few pieces of teabowls (see Plate 30), wine cups, bowls, and bottles have been found. The clay is rich in iron and is not very refractory. Foot rims are trimmed low. Only a few types of glaze are used—iron oxide and wood ash being predominant. Pots are glazed all over and are frequently blistered or bloated because they were not bisqued prior to glazing. This method of glazing the green pot is known as *namagake*.

For some unknown reason, the Jōbata kiln was suddenly closed down—probably, to judge from a document of 1607, five or six years after its construction. In this document, Nagamasa ordered the officer in charge of the clan's navy to prepare to ship some Korean potters back to their country. However, another theory is that the experimental kiln at Jōbata was closed down and the potters released from their duties because their products were all too similar to those of the Takuma kiln (see below).

It is of interest to note here with regard to the way

in which foreign potters were treated, that the authorities either made those in charge of the clans' outpost castles keep watch over the potters or insisted that the influential Shinto shrines or Buddhist temples register the potters' names in the parish records. Thus the feudal lords were not just their supervisors, but also, in a manner of speaking, their protectors.

The Takuma Kiln

Jōbata is apparently the earliest Takatori kiln, but the Takuma kiln produced the first official Kuroda clan ware. Situated at the foot of Mt. Takatori, in the eastern part of present-day Nōgata City, the Eiman-ji Takuma kiln is in fact only one kilometer south of Sarayama Hongama, the official kiln of Agano ware, produced for the Hosokowa clan in Buzen Province.

The kiln was probably established in 1606 and was active for about eight years until its closure in 1614. Literary sources attribute its origin either to Hachizō or to Shinkurō. In all probability, Shinkurō, who was Hachizō's father-in-law, was the leading potter at the Takuma kiln, for it is known that Hachizō really only began to assert his own style following his move to Uchigaiso some eight years later. Although the reasons for this move are far from clear, it may be that the workshop was transferred from Takuma because of the impending demolition of Takatori Castle in 1615 at the command of the central government in Edo.

Korean influences can be seen in the glazes used on the wares fired in the Takuma kiln. The rice-straw-ash and *namako* blue glazes are to be found on wares originating in the famous Korean ceramic centers of Nüchen and Hoeryŏng, and it is known from historical sources that the daimyo Katō Kiyomasa marched through these areas in the north of Korea during his campaigns in that country. These and a wood-ash glaze were also used on Takuma wares, and the glazes are in fact so similar to those found on Jōbata kiln pots that it seems most probable that potters went to work in Takuma once they left the Jōbata kiln.

Pieces made at the Takuma kiln were mostly large or small dishes, bowls with or without pouring spouts, and saké cups. Also, though seldom, found are tea jars, amber-glazed lidded jars, saké bottles, steamers, and such tea ceremony objects as tea caddies and teabowls (Plate 31).

Pots appear to have been thrown singly rather than off the hump, and the foot rims are only roughly trimmed. The section of the pot just above the foot rim tends to be thick, and in the case of jars, the walls frequently have been trimmed down (Plate 28). Foot rims are generally very low and this, together with the thickness of the clay body, gives these pots a rather coarse, sturdy effect. However this effect is offset somewhat by the elegance of the opaque straw ash and *namako* glazes (Plate 29).

The Uchigaiso Kiln

Potters making Takatori ware appeared destined never to settle down, for time and time again they were forced to move to new kiln sites. The kiln that follows the Jōbata and Takuma ware period is known as *Uchigaiso-gama*. It was at Kamano-o in the valley of Uchigaiso that the potter Hachizō is said to have set up a workshop and begun to produce porcelain wares at the command of Kuroda Nagamasa in about 1614 (see "The Sequel to the History of Chikuzen Province"). However, according to the "Brief History of the Administration of Fukuoka Fief" *(Fukuoka-han minsei shiryaku)*, Hachizō was joined by another potter called Igarashi Jizaemon. The latter had been in the service of the Terasawa family in Karatsu but had lost his job there. Nagamasa's son, Kuroda Takayuki, decided to employ him because he was skilled at making porcelain, and so Jizaemon was sent to live at Takatori and work at the Uchigaiso kiln. The two potters are said to have moved around quite a bit thereafter, seeking suitable clay materials.

Hachizō was favorably treated and paid a stipend equivalent to the rations of seventy men as well as being given a tax-free estate of over two *chō* (about 20,000 square meters) of fields in the neighborhood. Upon the death of Nagamasa, who was his most understanding patron, Hachizō applied to Tadayuki for permission to return to his home country, but his request was considered to be nothing short of insolence, and Hachizō was kept at a secluded workshop at Tōjin-dani ("Chinese Valley") at Yamada for some time.

The Uchigaiso kiln is thought to have been closed after ten years' production in 1624, the year following the death of Nagamasa. The potters there dispersed, some of them apparently migrating to Agano ware workshops, while Hachizō moved to Yamada.

Hachizō's part in the Uchigaiso kiln's production appears to have been quite important. That he was the leading potter may be seen from a recently unearthed cylindrical flower vase on the bottom of which is stamped his name with the Chinese character for king. This same character appears on the bottom of a low-standing water container (Plate 32), which is in the Oribe style and is very rare among old Takatori wares.

The influence of Oribe, who succeeded Sen no Rikyū as the leading tea master in the country, continued long after his death, and many of the Uchigaiso wares reveal Oribe's taste. This may be seen in the "shoe" form teabowls, "folded" serving dishes, combed flower vases, wood-ash-glazed water containers with handles, candlesticks in the shape of European figurines, and so on.

Among Takatori wares in general, pots fired at the Uchigaiso kiln show a particularly rich variety of techniques. Shards of angular-shouldered, straw-ash-glazed jars with the clay body unglazed at the bottom have been unearthed only at this Takatori kiln site, and are generally classified as "mottled Karatsu" (*madara Karatsu*) wares. All in all, the wares produced at Uchigaiso are full of the dynamic spirit one would expect of the Momoyama period.

The Yamada Kiln

About thirty kilometers south of Uchigaiso, abutting the present city of Iizuka, is Tōjin-dani ("Chinese Valley") at Kijiro in what is now Yamada City. The area around the kiln site is now a coal-waste dumping ground. No vestige of the past remains except a stone monument reading "Site of the Yamada Kiln of Old Takatori." Hachizō and his son had their factory here for six years after 1624.

Because the kiln site is in such a sad state of preservation, it has not been possible to excavate shards at all, and so there are extremely few specimens from the kiln intact. The two teabowls shown in Plates 48 and 50 were reportedly discovered in the tomb of a man called Ōba. Published for the first time here, they are valuable examples of Yamada kiln wares. They show an uninhibited style by potters, who, though free from restriction, worked in some adversity. Like other early Takatori wares, they are relatively thickly thrown, but their straw-ash glaze is pleasant, soft, and recalls that of the

Takuma kiln, giving the elegant, warm effect peculiar to stoneware pottery.

Documentary evidence reveals that Igarashi Jizaemon worked for the Kuroda clan during the period in which Hachizō and his family led a secluded life at Yamada.

The Sengoku Kiln

After the Uchigaiso kiln was disbanded, most of the hundred or more potters who are thought to have worked there went to the Agano ware kilns of Kamanokuchi and Iwaya Kōrai. The few remaining potters adhering to the Takatori tradition appear to have built a new kiln at Sengoku Tōjin-machi, Miyata Town, in Kurate County.

Trailing glaze with a bamboo tube on a bisque-fired body was almost the only glazing technique used at the Sengoku kiln. Compared with the trailing found on works of other kilns, the Sengoku designs are outstandingly novel and fresh.

ENSHŪ TAKATORI PERIOD

The Shirahatayama Kiln

Having obtained the permission of Takayuki, Hachizō, after his period of seclusion at Yamada, built an official factory at the foot of Shirahatayama at Aiya Village in Honami County (present-day Kōbukuro-machi in Iizuka City), where he began to make porcelain again from about 1630. He was provided with a stipend of eight *koku* (one *koku* being approximately five bushels of rice) plus rations sufficient for eight men and an estate of something more than two *chō* of rice fields.

Hachizō and his son, now once again potters in official service, worked with rekindled hope and made various experiments. Tadamasa sent them to study how to make tea ceremony objects under Kobori Enshū, who praised them highly for the quality of their work. The period of thirty-five years following this, until the workshop moved to Tsutsumi in Koishiwara Village, is called the Enshū Takatori period. It was around this time that Takatori ware began to exhibit the tea ceremony ceramic art style and move away from its Korean antecedents.

Igarashi Jizaemon, mentioned above in connection with porcelain production at Uchigaiso, was also well versed in the ceramic techniques of Seto. His

collaboration with Hachizō led to the adoption of the Seto technique of overglazing (Plates 45, 47) and to the development of burnished thin-walled pieces instead of the rustic wares that characterized the earlier kilns. The major products were now tea ceremony objects such as tea caddies, teabowls, and water containers. Tea caddies, especially, had lids made for them and covered a wide range of forms: *minakuchi* (wide mouthed), *taikai* (large, short, and wide mouthed), *katatsuki* (with angular shoulders), *bunrin* (apple shaped), *mimitsuki* (eared), *nasu* (egg-plant shaped), and so on. This period gave birth to tea caddy masterpieces, which have been unsurpassed in the history of Takatori ware: for instance, the caddies named "Somekawa," "Yokodake," and "Aki-no-yo."

Many teabowls, water containers, and wall vases also exist with fine horizontal sgraffito combing around the sides. It was from this period, too, that the Takamiya transparent glaze, which was to become the hallmark of Takatori ware in later times, was first experimented with frequently on these thin-walled pieces.

The kiln site at Shirahatayama has yielded kiln stilts with porcelain fragments adhering to them, along with whetstone masses and a porcelain test piece inscribed Hita (presumably the town of that name). Whetstone is a material used in porcelain clay. This suggests that porcelain was experimented with here in earnest, a fact that is hardly surprising in view of the yearning most feudal lords had for this ceramic during the Edo period.

A large number of porcelain pieces were discovered in the tombs of Hachizō I and his close relatives when their remains had to be exhumed and reburied recently. Hachizō's tomb, in particular, yielded blue-and-white porcelain, teabowls, tea cups, and saké cups. It is thought that the Shirohatayama workshop may have been moved to Nakano in Koishiwara Village because the latter was near Hita, where porcelain stone was available. This occurred some ten years after both Tadayuki and Hachizō died in the same year of 1654.

KOISHIWARA TAKATORI PERIOD

The Tsutsumi Kiln
Hachirō Shigefusa, grandson of Hachizō, moved from Shirahatayama to Tsutsumi in 1665, when Mitsuyuki was lord of the Kuroda clan. It is said that his younger brother Hachinojō remained at Shiraha-tayama and occasionally assisted the elder sibling at the latter's "tea caddy kiln" (*chaire-gama*), so called because almost the entire production until the end of the Edo period consisted of tea caddies. Word has it that a globular tea caddy made here was named "Yōhen" ("Kiln Change") by Kobori Enshū himself, who wrote this term on the box housing the caddy. The pot was treasured by Kuroda Mitsuyuki.

The Nakano Kiln
Hachinojō, grandson of Hachizō I, moved to Nakano in Koishiwara Village (present Koishiwara Sarayama), where he opened his factory in 1669. Later on, in 1682, Mitsuyuki invited other potters from Hizen to work there and make porcelain, chiefly copies of Chinese Ming dynasty pots. Not long after, however, the manufacture of porcelain was abandoned due to a shortage of materials. One can still find many porcelain shards at the kiln site, and this proves Mitsuyuki's unusual interest in porcelain, no doubt influenced by his father, Tadayuki.

According to the *Tsutsumi kamadoko*, the Kuroda clan had an official kiln at Nakano Sarayama. Here the Takatori and Igarashi families made ceramic wares for official use, but the officer in charge of ceramic production also arranged for everyday ware to be made for use by the local people, thereby contributing to the finances of the clan. This is probably the origin of the "folk" pottery that is now known as Koishiwara ware, currently produced at the village of Sarayama.

FUKUOKA SARAYAMA PERIOD

Higashi Sarayama
In 1708, the fourth Kuroda clan lord, Tsunamasa, invited potters from Koishiwara to Uenoyama, Sohara Village, Nishijin-machi, in the capital of his fief, Fukuoka. This kiln is called Higashiyama or Higashi Sarayama and was active until the Meiji Restoration, making pots for the Kuroda family. Its products were mainly tea caddies, teabowls, and alcove ornaments in the taste of Enshū, and they were reserved exclusively for use as gifts to the central government in Edo and to other feudal lords.

Nishi Sarayama

In 1718, the fifth Kuroda clan lord, Norimasa, ordered his retainer Yanase Sanemon to build a pottery kiln at Tontsurayama in Sohara Village. Sanemon invited a few potters from Koishiwara to come and cooperate with the craftsmen at the new kiln. This kiln was established as a means of increasing the clan's income and mainly made everyday wares. These were marketed by the clan's official distributor until the end of the feudal age.

Sue Ware

Takatori ware may be said to have begun with the Takuma kiln and to have lasted through many vicissitudes until the end of the feudal age in 1868. During this period, wares changed from a heavy, rustic Takuma style to a lighter, more elegant and delicate style in the taste of Enshū and also more Japanese in character than the original wares. While such change may in one sense be seen as progress, in another it resulted in the loss of some of those traits that pottery should have—for example, warmth in texture and workmanship, a power, and vitality. In short, the ware lost its very "heart."

I would have liked to discuss how porcelain fits into the history of Takatori ware, and the role of the Kuroda clan lords in its production, for it was they who were interested in white porcelain rather than in the more ordinary pottery. The seventh clan lord, Haruyuki, tried to revive porcelain at the Nakano kiln, where Mitsuyuki had earlier experimented, but gave up due to a shortage of materials and the inconvenient location of the kiln. He then looked for a more suitable place and eventually hit upon Sarayama, Sue Town, Kasuya County, where he invited Hizen and Takatori potters to come and work. This was the origin of Sue ware.

The site of the Uchigaiso kiln under the first lord,

Nagamasa, has yielded shards of porcelain with copper-red underglaze. The Shirahatayama kiln under the second lord, Tadayuki, saw some success in the production of blue-and-white porcelain, but he died in the same year as Hachizō, and the factory did not succeed in full-time manufacture of porcelain. Later on, the third lord, Mitsuyuki, moved the workshop to Nakano, which was conveniently situated so far as access to porcelain stone was concerned. Here he got porcelain craftsmen, whom he had invited from Hizen, to repeat experiments, but these failed, and the kiln reverted to firing thin-walled stoneware.

The Nakano kiln was active thereafter as the clan's official kiln for about ten years, during the An'ei era (1772–81), until the death of Haruyuki. Later it was closed down and then transferred to a private manufacturer, who tried but failed to revive it at his own expense.

The eleventh clan lord, Nagahiro, established an office supervising ceramic manufacture at Sue in 1860, and under this office the clan's official kiln was reopened and pots mass-produced. During the Man'en era (1860–61), potters and painters were invited there from Kyoto, Seto, and Hizen; the workshop was provided with forty-four clay crushers, and Sarayama even had its own currency issued to enhance its financial resources. This pottery manufacture thrived.

The quality of the material used, together with the technical ability of the potters and decorators working there, led to the production of excellent work at this Sue kiln. Unfortunately, the kiln had to be closed down in 1870 after the Meiji Restoration, less than ten years after its revival. Thus, porcelain manufacture was finally perfected during the time of the eleventh clan lord, Nagahiro, who fulfilled the dreams of his ancestor, the first lord, Nagamasa.

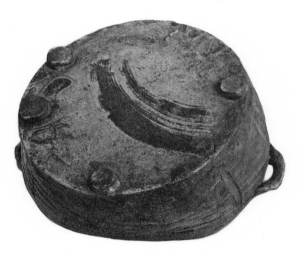

Bottom of pot in Plate 32; at the left the Chinese character 王, meaning "king."

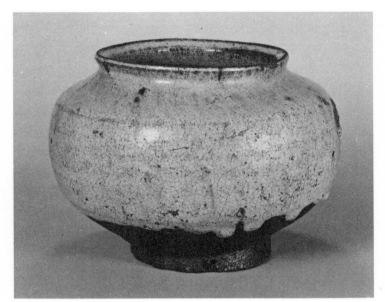

Jar with white rice-straw-ash glaze. The bottom of the jar is unglazed.

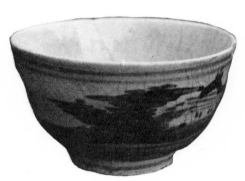

Porcelain bowl, Shirahatayama kiln.

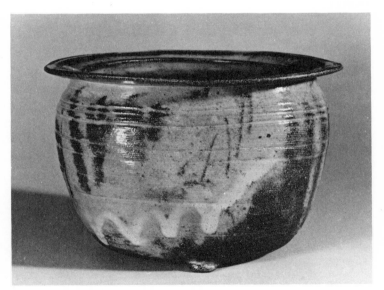

Water container with fine combing, Shirahatayama kiln.

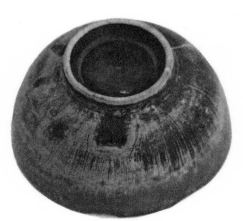

Bowl, Nakano kiln.

15

Agano Ware

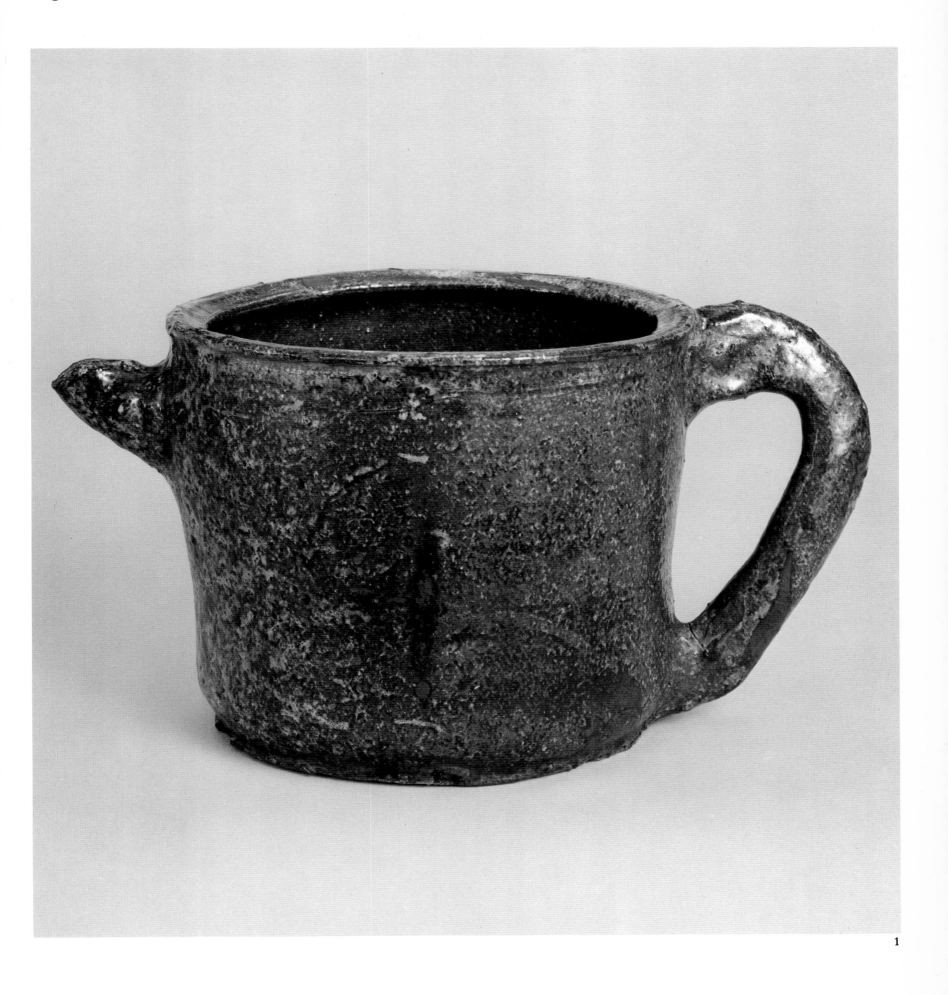

1

1. Ewer, ash glaze. H. 12.9 cm. Early seventeenth century. Tanakamaru Collection.

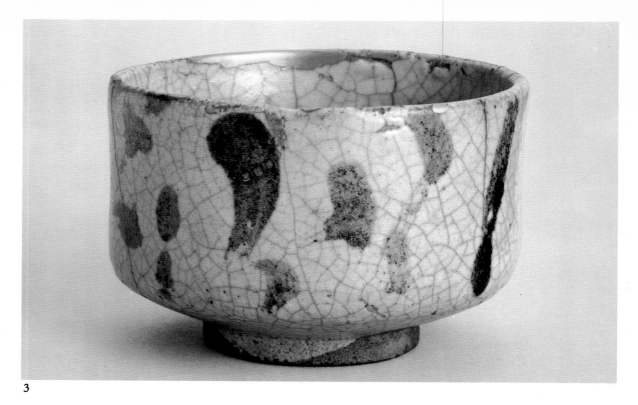

3

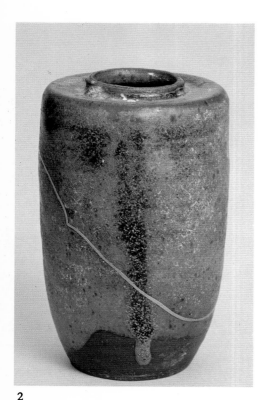

2

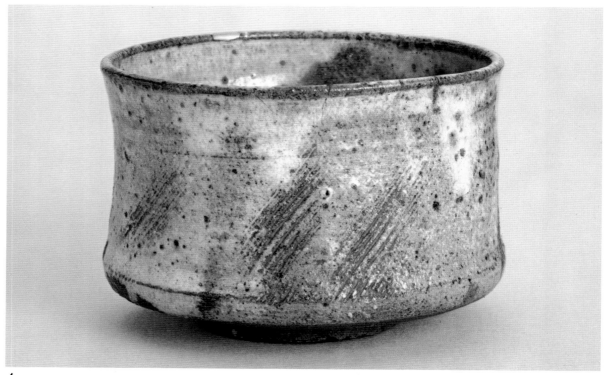

4

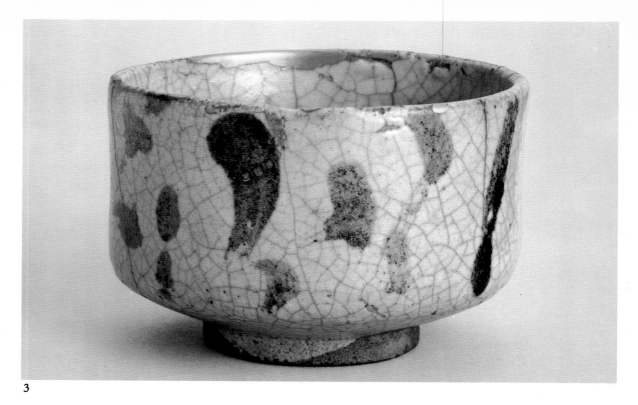

*2. Square-shouldered tea caddy, amber glaze. H.
8.3 cm. Early seventeenth century.*

*3. Teabowl, iron oxide painting and feldspar glaze.
D. 10.4 cm. Early seventeenth century. Idemitsu
Museum of Art.*

*4. Combed teabowl, rice-straw-ash glaze. D. 11.5 cm.
Early seventeenth century. Idemitsu Museum of Art.*

*5. "Split pod" (wari-zanshō) food bowl, ash glaze.
H. 8.0 cm. Idemitsu Museum of Art.*

5

18

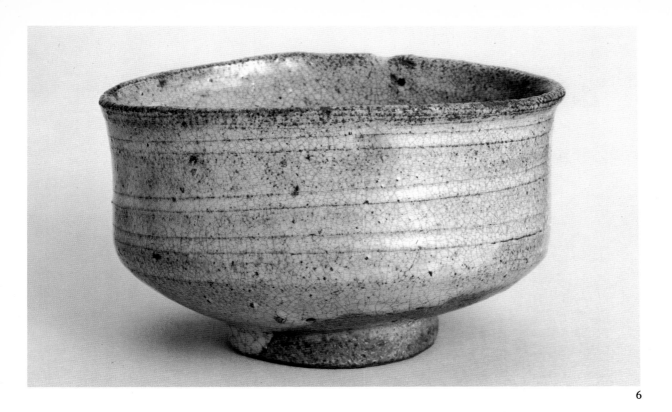

6

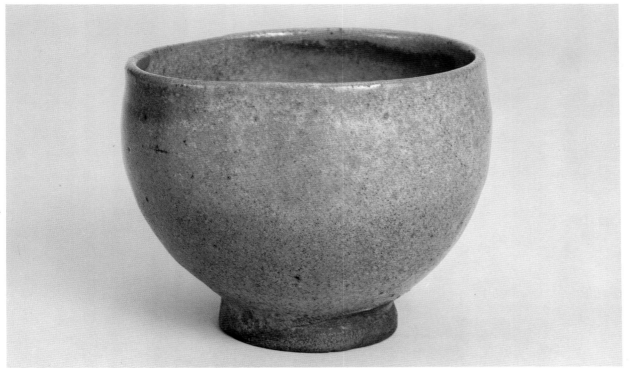

7

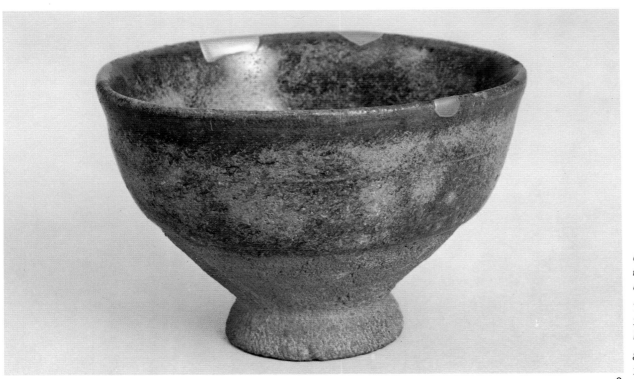

8

6. "Shoe-" shaped teabowl, rice-straw-ash glaze, named "Fugen." D. 13.7 cm. Early seventeenth century. Idemitsu Museum of Art.

7. Teabowl, ash glaze, named "Kokura-yaki." D. 10.2 cm. Early seventeenth century. Tanakamaru Collection.

8. Goki-shaped teabowl, rice-straw-ash glaze. D. 11.1 cm. Early seventeenth century.

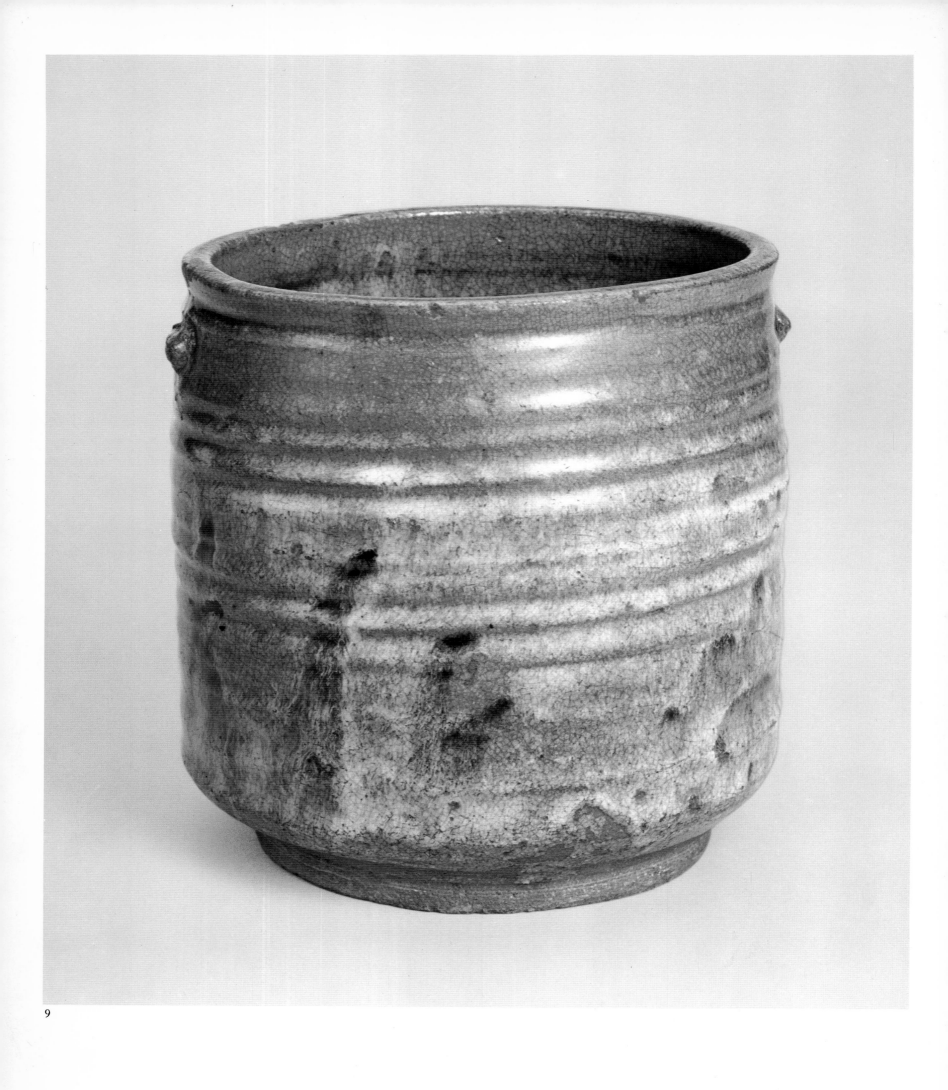

9

9. *Tea ceremony water container with handles, ash glaze over iron oxide. H. 15.5 cm. Early seventeenth century. Tanakamaru Collection.*

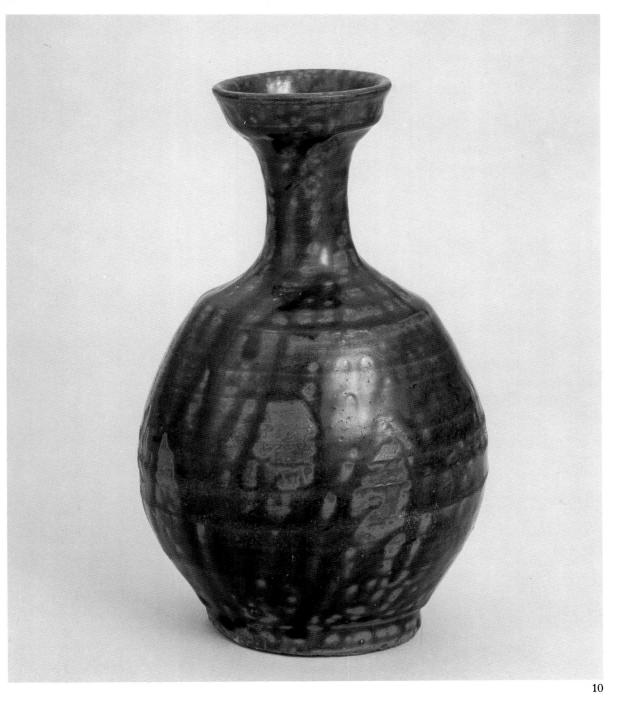

10

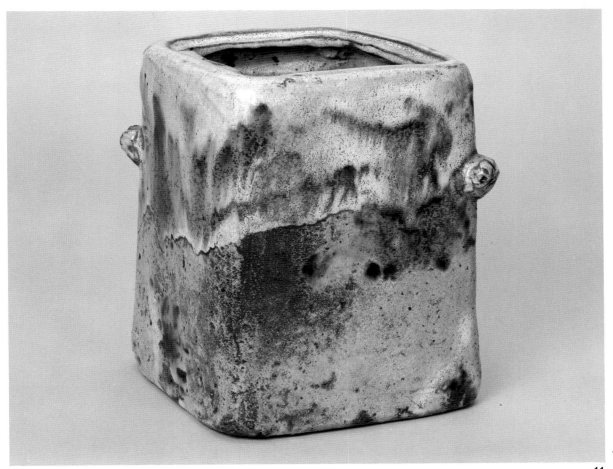

11

10. *Saké bottle, amber glaze. H. 24.8 cm. Early seventeenth century.*

11. *Square water container, rice-straw-ash and green glazes. H. 19.0 cm. Early seventeenth century. Tanakamaru Collection.*

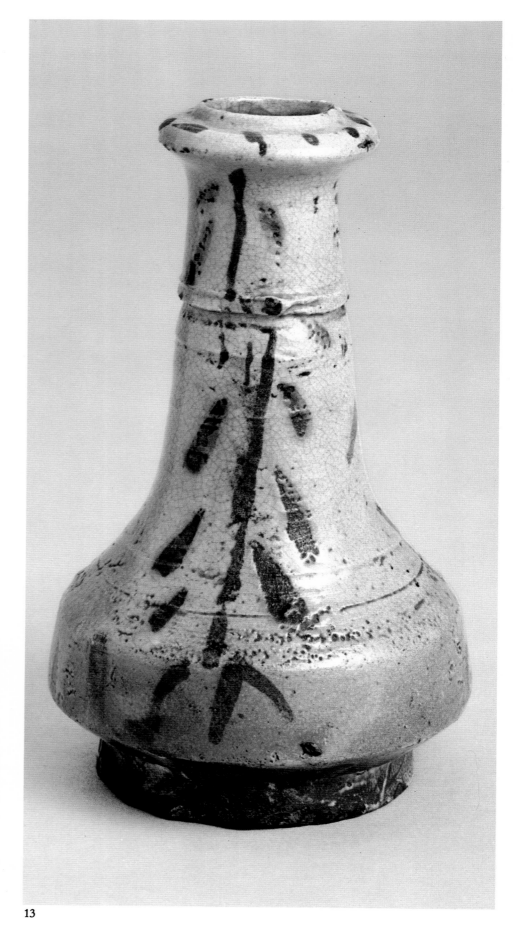

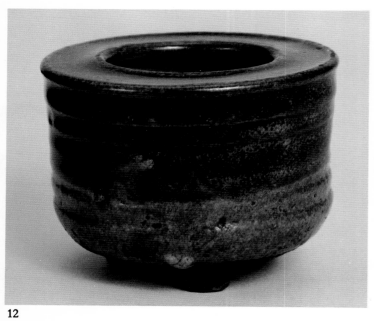

12

13

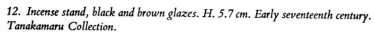
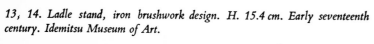
12. *Incense stand, black and brown glazes. H. 5.7 cm. Early seventeenth century. Tanakamaru Collection.*

13, 14. *Ladle stand, iron brushwork design. H. 15.4 cm. Early seventeenth century. Idemitsu Museum of Art.*

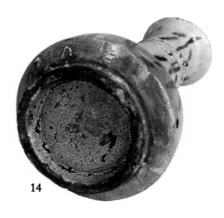
14

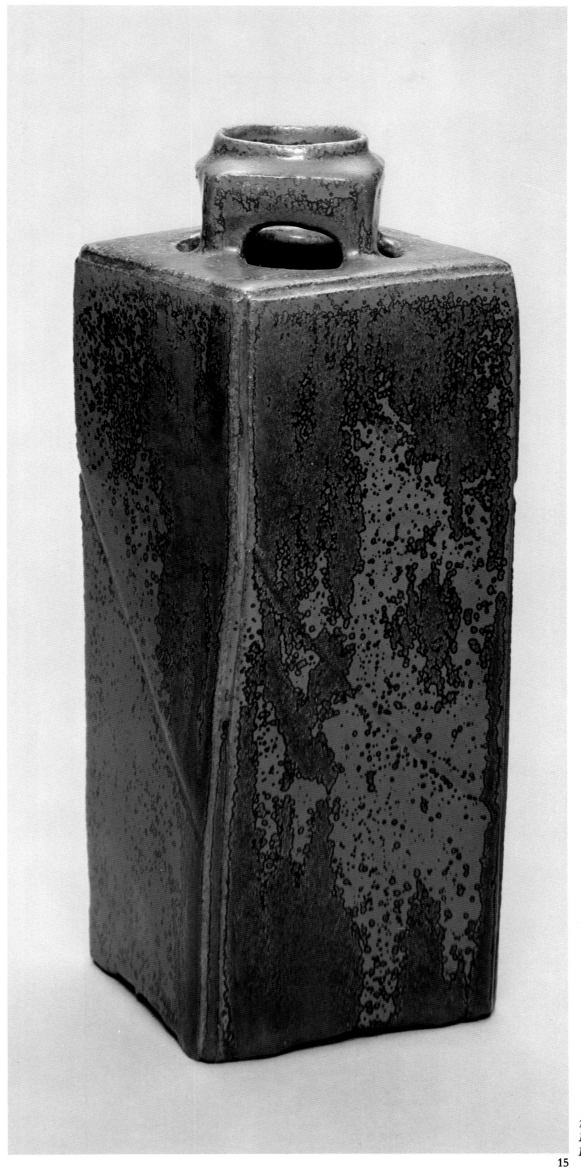

*15. Rectangular vase, green glaze.
H. 31.5 cm. Late nineteenth century.
Idemitsu Museum of Art.*

15

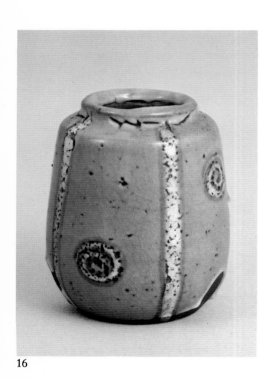

16

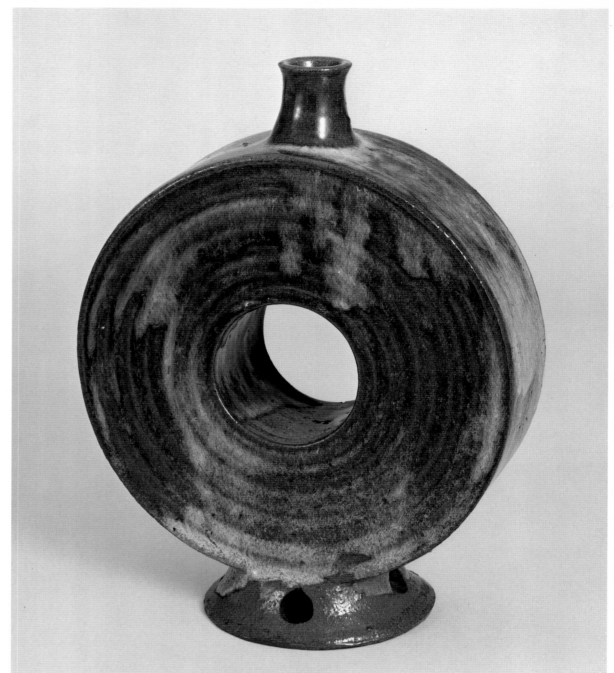

17

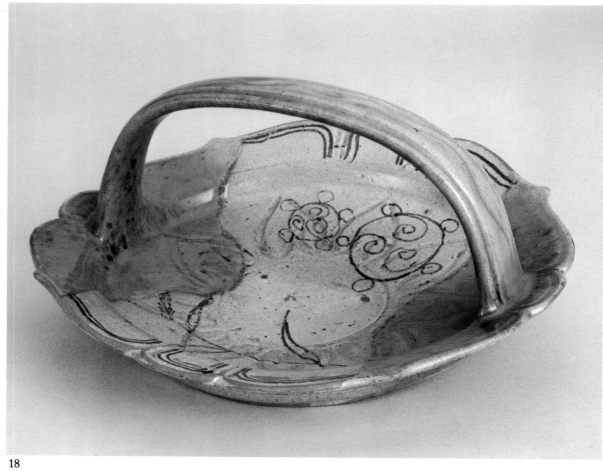

18

16. Tea caddy, mishima *style. H. 7.0 cm. Late eighteenth century.*

17. Flattened ring-shaped bottle, rice-straw-ash glaze. H. 26.5 cm. Late eighteenth century.

18. Handled dish, green glaze and iron pigment painting. Greatest D. 27.4 cm. Late eighteenth century. Idemitsu Museum of Art.

AGANO WARE EFFECTS

19. *Running glaze* (rokushō-nagashi)
20. *Wood-grain* (mokume)
21. *Three-color* (sansai)
22. *Inlay* (zōgan)
23. *Fine trailing* (sōmen-nagashi)
24. *Paddling effect* (ki-tataki)
25. *Egg-yolk yellow* (tamago-de)
26. *Combing* (kushime)

19

20

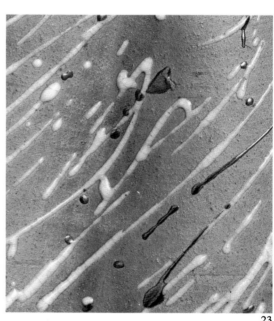

21

22

23

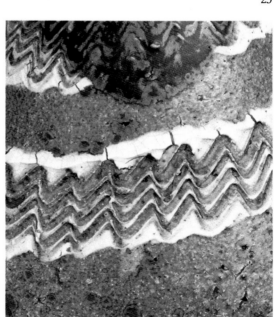

24

25

26

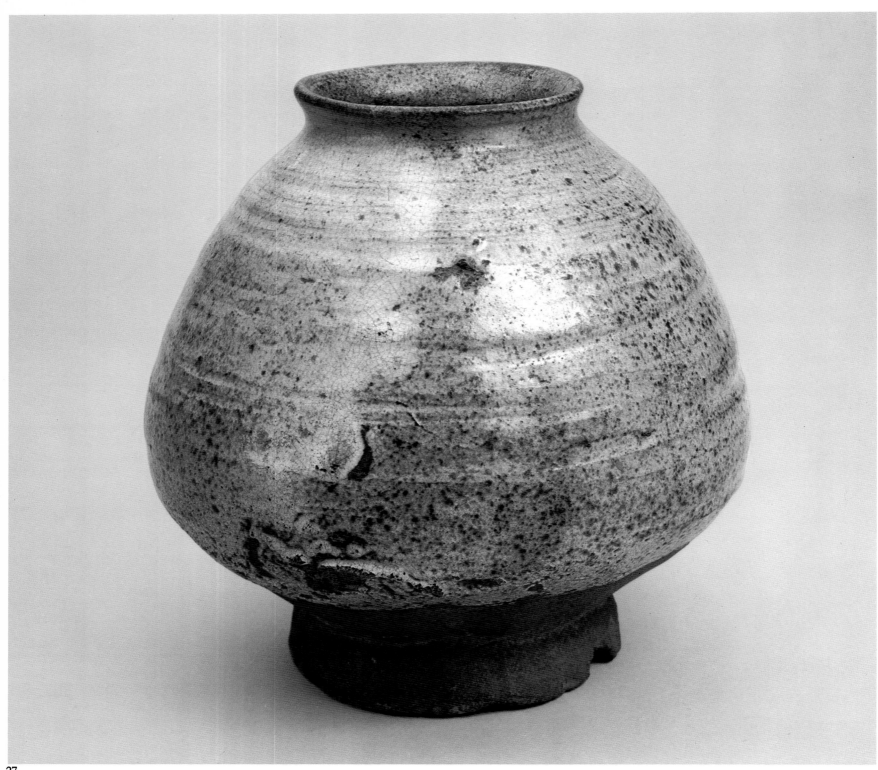

27

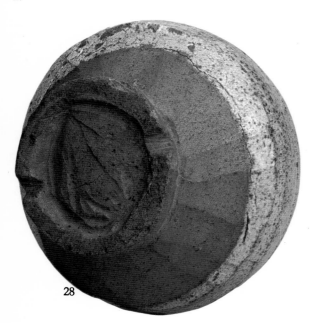

28

27, 28. Large jar, rice-straw-ash glaze. H. 22.8 cm. Early seventeenth century. Idemitsu Museum of Art.

26

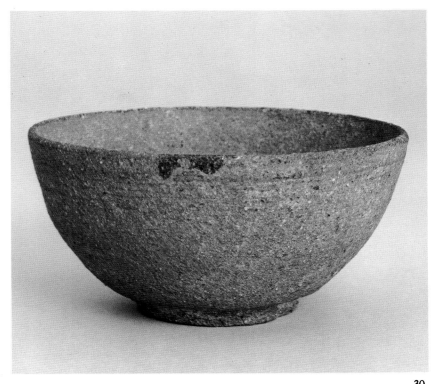

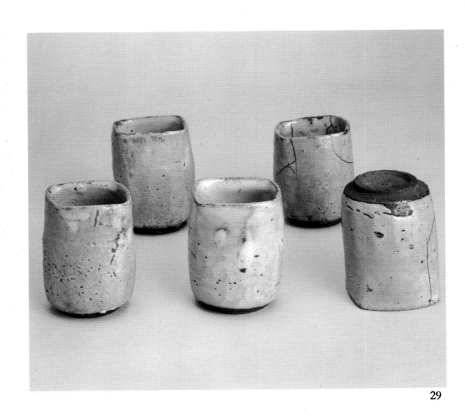

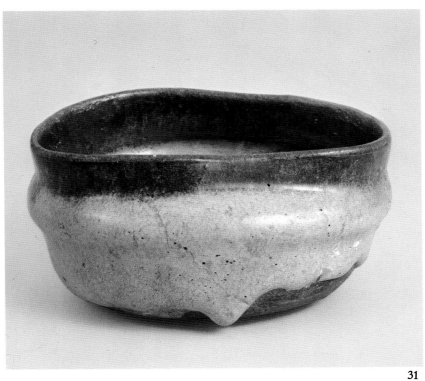

29. *Deep square food bowls, rice–straw–ash glaze. H. 9.5 cm. Early seventeenth century. Idemitsu Museum of Art.*

30. *Teabowl, ash glaze. D. 12.5 cm. Early seventeenth century.*

31. *"Shoe–" shaped teabowl, rice–straw–ash glaze. H. 7.9 cm. Early seventeenth century.*

32. *Squat water container, ash glaze. H. 8.3 cm. Early seventeenth century. Tanakamaru Collection.*

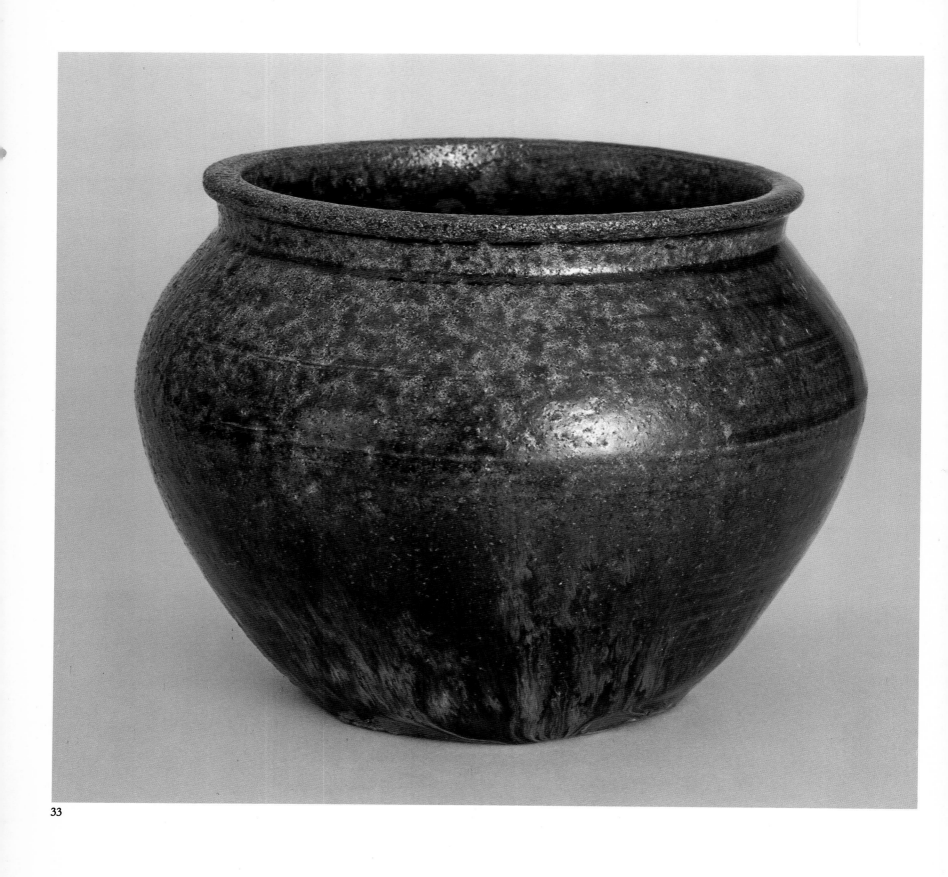

33

33. Jar, rice-straw-ash glaze. H. 17.0 cm. Early seventeenth century.

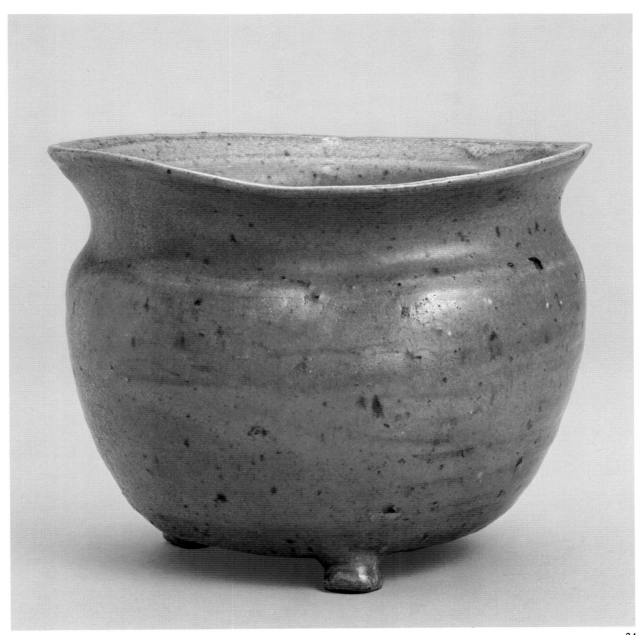

34

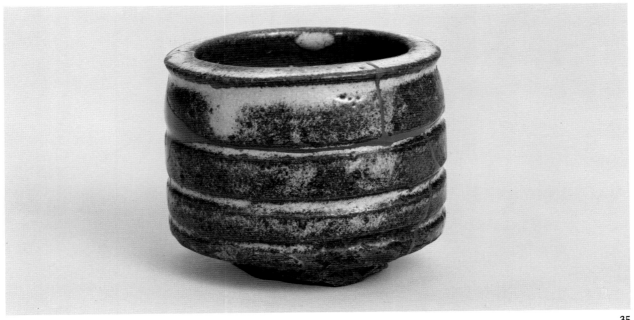

35

34. Three-legged water container, rice-straw-ash glaze. H. 14.5 cm. Early seventeenth century. Idemitsu Museum of Art.

35. Incense stand, rice-straw-ash glaze. H. 6.5 cm. Early seventeenth century.

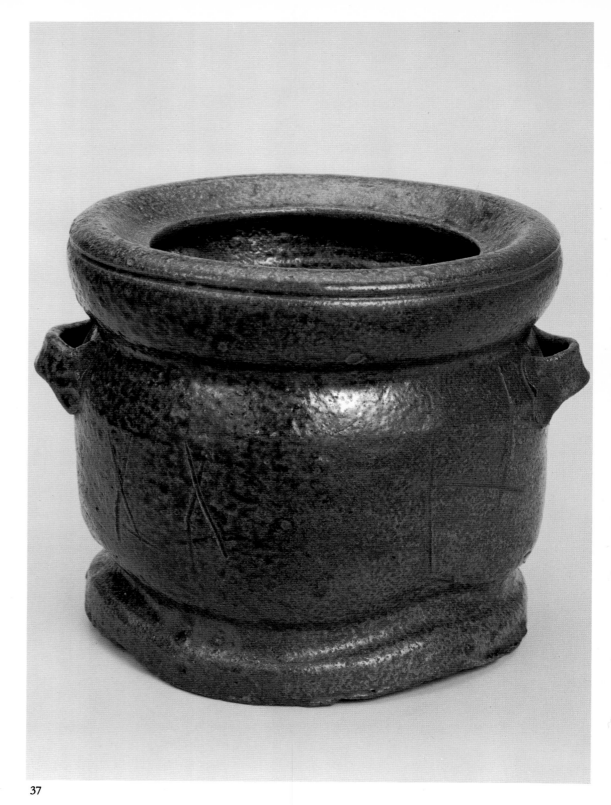

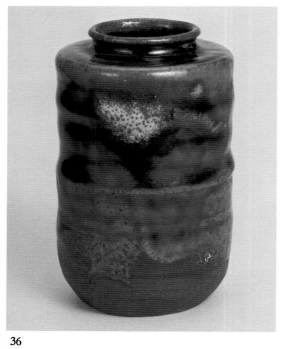

36

37

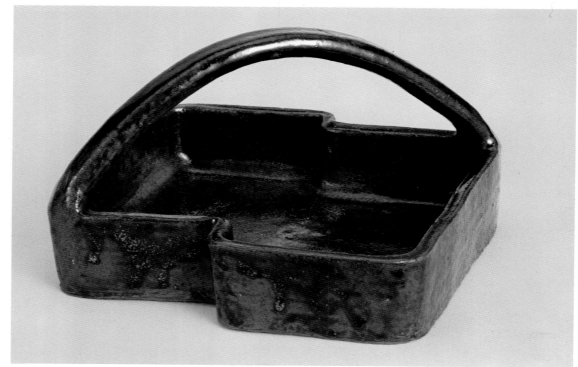

36. Square-shouldered tea caddy, amber glaze. H. 8.3 cm. Early seventeenth century. Tanakamaru Collection.

37. Water container, ash glaze, incised line decoration. H. 18.3 cm. Early seventeenth century.

38. Molded and handled dish, amber glaze. Greatest L. 17.5 cm. Early seventeenth century. Tanakamaru Collection.

38

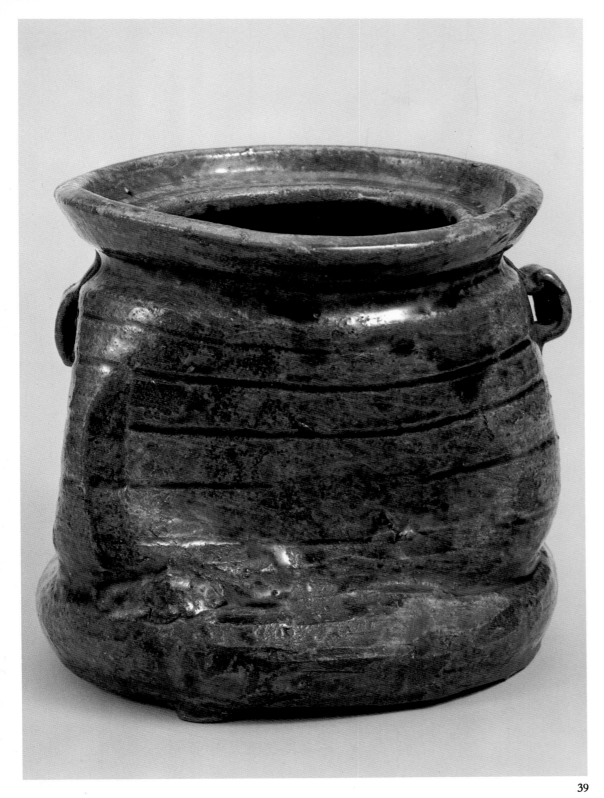

40

39

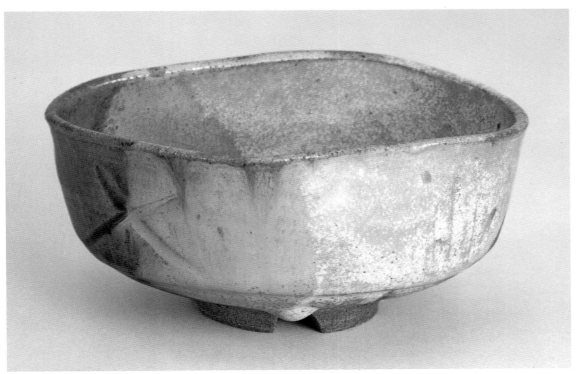

41

39, 40. *Lugged water container, ash glaze. H. 15.5 cm. Early seventeenth century.*

41. *"Shoe-" shaped teabowl, rice-straw-ash and iron glazes. H. 7.0 cm. Early seventeenth century.*

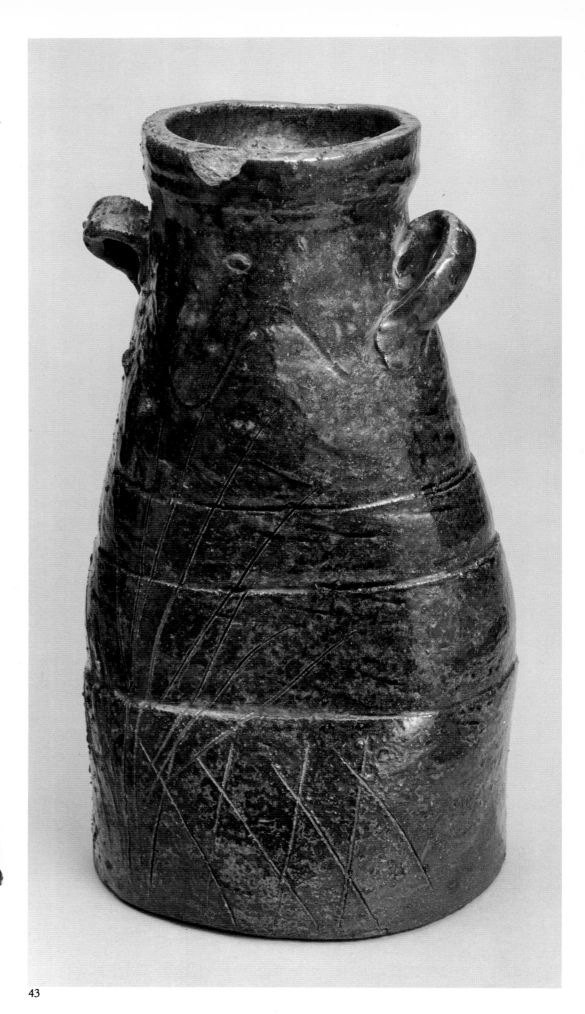

42

43

42, 43. Wall vase, ash glaze, incised line decoration. H. 21.8 cm. Early seventeenth century. Idemitsu
Museum of Art.

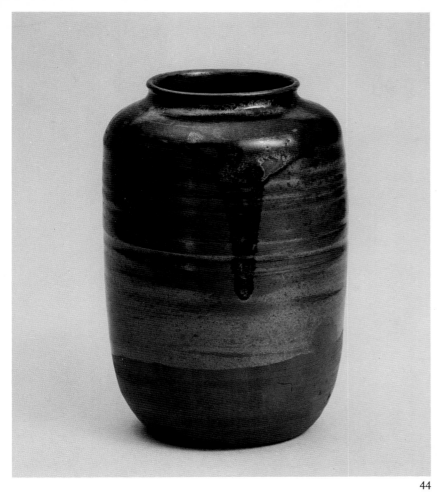

44

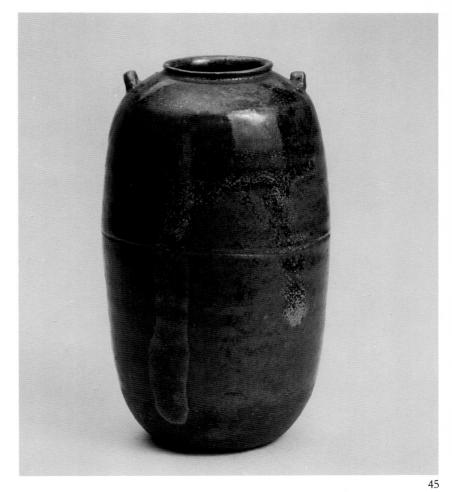

45

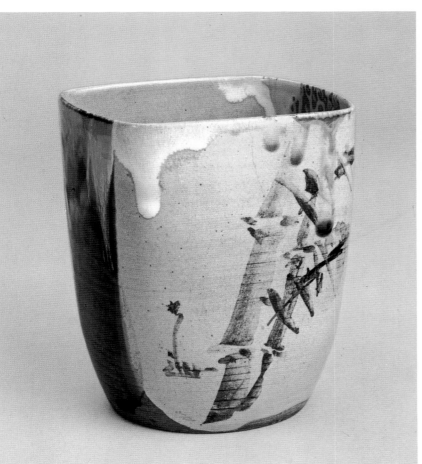

46

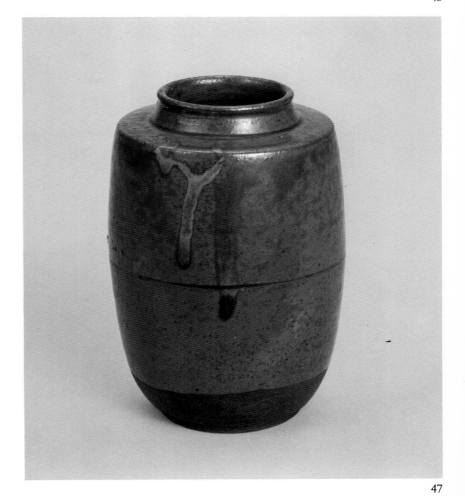

47

44. Tea caddy, Koishiwara ware, named "Yamaji." H. 7.0 cm. End of seventeenth century. Idemitsu Museum of Art.

45. Eared tea caddy, Shirahatayama ware. H. 10.5 cm. Middle seventeenth century. Idemitsu Museum of Art.

46. Water container, decoration painted by Priest Sengai. H. 15.0 cm. Early nineteenth century. Idemitsu Museum of Art.

47. Square-shouldered tea caddy, Shirahatayama ware. H. 6.5 cm. Middle seventeenth century.

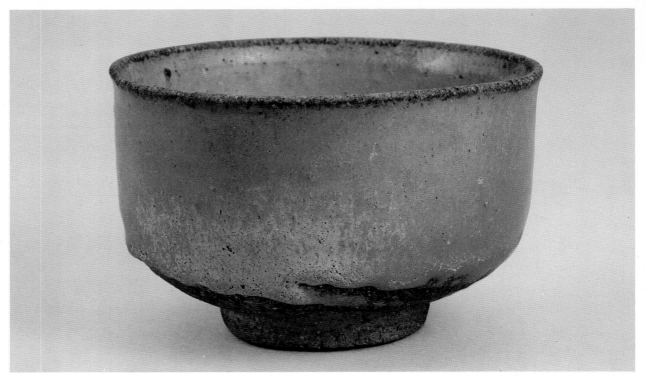

48

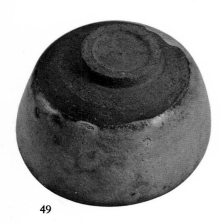

49

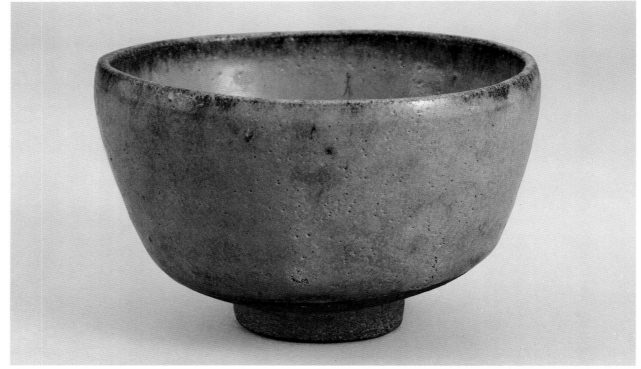

50

48. *Teabowl, rice-straw-ash glaze. H. 14.0 cm. Early seventeenth century. Yamada City Office.*

49, 50. *Teabowl, rice-straw-ash glaze. D. 14.4 cm. Early seventeenth century. Yamada City Office.*

51. *Teabowl, ash glaze. D. 14.6 cm. Middle seventeenth century. Tanakamaru Collection.*

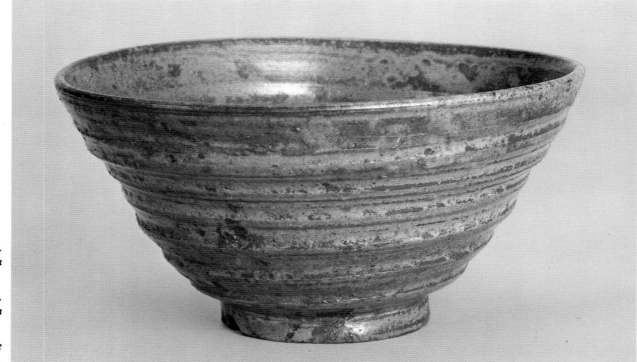

51

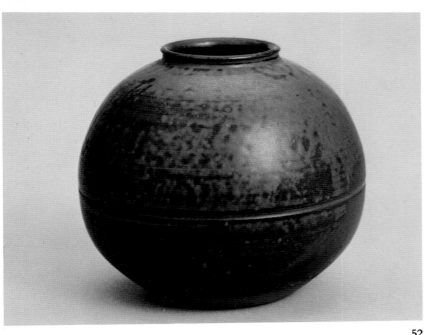

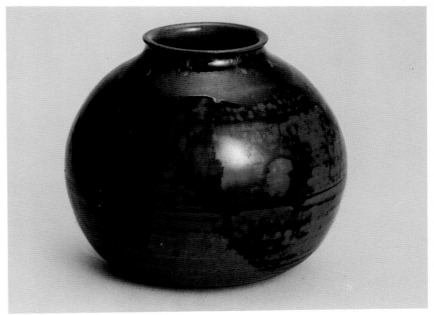

52

53

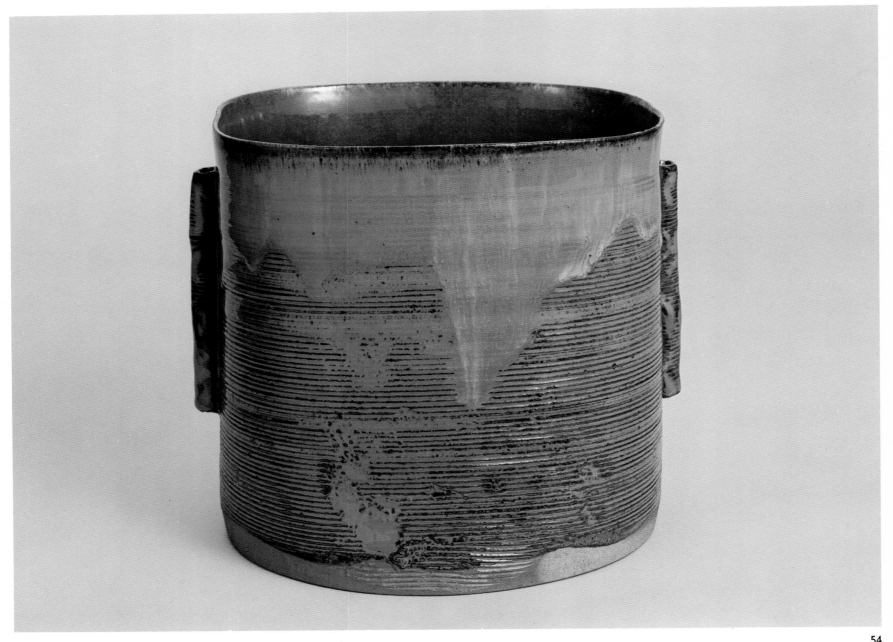

54

Modern Potters

52. Apple-shaped tea caddy. Agano ware by Kōyō Kumagaya. H. 7.5 cm.

53. Bggplant-shaped tea caddy. Takatori ware by Miraku Kamei. H. 6.5 cm.

54. Square water container with cylindrical lugs, by Hassen Takatori. H. 21.0 cm.

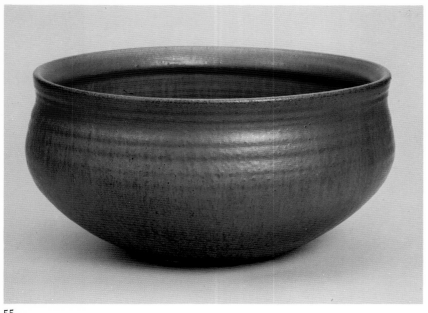

55

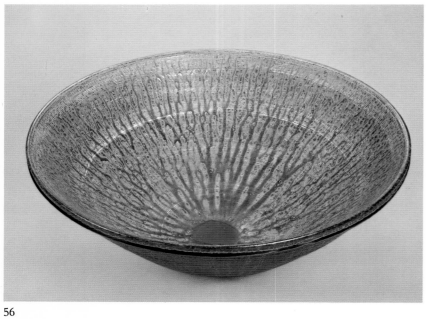

56

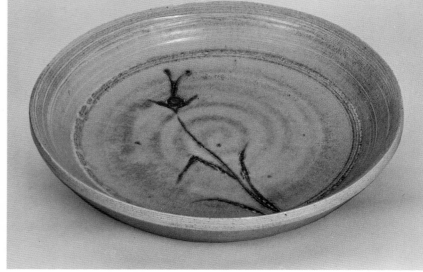

57

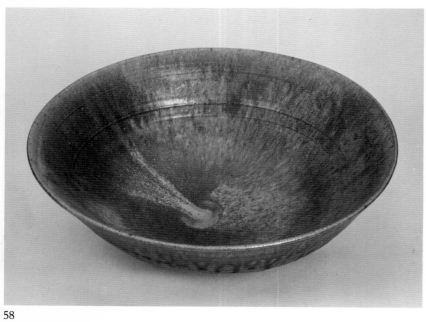

58

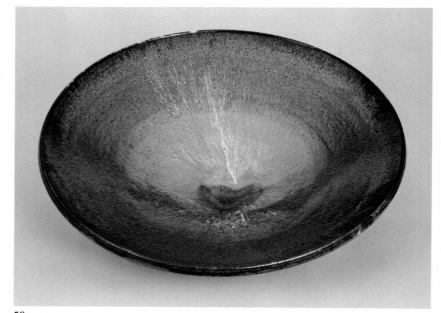

59

55. Bowl, brown glaze, by Takahisa Watari. Mouth D. 36.0 cm.

56. Large bowl, ash glaze, comb markings, by Fujinori Kajiwara. D. 60.0 cm.

57. Large dish, ash glaze, flowering grass design. Agano ware by Yasuoki Kumagai. D. 42.0 cm.

58. Large bowl, carbonized amber glaze, by Jun Kōzuru. D. 51.0 cm.

59. Bowl, iron glaze, by Nobuhiko Shirakawa. D. 48.5 cm.

Plate Notes

Agano and Takatori wares were first fired in northern Kyushu in the early Edo period. Both of them were a result of Japan's military excursions into Korea during the Bunroku (1592) and Keichō (1597) eras, and both were initiated by feudal lords.

AGANO

1. *Ewer, ash glaze. H. 12.9 cm. Early seventeenth century. Tanakamaru Collection.*
This is a straight-sided jug typical of Kamanokuchi ware. The wood-ash glaze underwent chemical change during firing, when it was coated with ash from the pine wood used to fire the kiln. The mouth is in a sloping inverted form termed *sembei-guchi*. The handle was not pulled but hand-modeled and simply stuck on to the side of the jug. The base has not been trimmed in any way, and the mark of the string used to cut the pot from the wheel can still be seen. The jug was placed on sand during firing. Vessels of this kind have been unearthed in large numbers, and range in shape from bottles and kneading bowls to saké cups, water containers, and so on.

2. *Square-shouldered tea caddy, amber glaze. H. 8.3 cm. Early seventeenth century.*
Pieces of this kind have hitherto been mostly classified as Takatori ware, but this one was unearthed at the site of the Kamanokuchi kiln. It has a thin-walled body of ferruginous clay, covered with an amber glaze. The thick glaze is particularly effective where it has run down the side of the pot. The caddy is an important source of information about old Agano ware.

3. *Teabowl, iron oxide painting and feldspar glaze. D. 10.4 cm. Early seventeenth century. Idemitsu Museum of Art.*
This short cylindrical bowl is decorated freely and powerfully in iron oxide and covered with a thick feldspar glaze, which is applied also in four dots on the foot rim. The body is made from a coarse sandy clay, and the foot rim is short and circular. This shows that the bowl was made after Agano ware had been influenced by Takatori techniques, as a result of the arrival in the Kamanokuchi workshop of a number of potters from the Takatori kiln at Uchigaiso.

4. *Combed teabowl, rice-straw-ash glaze. D. 11.5 cm. Early seventeenth century. Idemitsu Museum of Art.*
The ferruginous clay has been marked with a bamboo comb and covered with a straw-ash glaze. This method of comb decoration is known as *neko-gaki* ("cat's claw") and

is probably an imitation of bowls made at Kimhae in Korea. The bowl apparently belongs to the last period of the Kamanokuchi kiln.

5. *"Split pod" (wari-zanshō) food bowl, ash glaze. H. 8.0 cm. Idemitsu Museum of Art.*
Celebrated as "Kokura ware" among old Agano products, this piece is mentioned as a "Kokura dish" in the record of a tea ceremony party held by Hosokawa Sansai. Its *wari-zanshō* (roughly meaning "split pod") form is regular, retaining an unaffected grace. The ash glaze peculiar to the Kamanokuchi kiln covers the entire surface, including the base. The bowl was placed on sand during firing.

The deep clefts between the petals and the indentations at their tips are very natural in appearance. Although this is a *mukōzuke* food vessel for raw fish or vinegared vegetables used in the light meal served during the tea ceremony (*kaiseki*), the general form of pot is like that of a teabowl. This is probably the prototype of the *wari-zanshō* form. Later examples are three-petaled, often having the foot rim carved out into a three-legged form, and are decorated with iron brushwork.

6. *"Shoe-" shaped teabowl, rice-straw-ash glaze, named "Fugen." D. 13.7 cm. Early seventeenth century. Idemitsu Museum of Art.*
The bowl has three horizontal grooves, obviously an effect produced by the potter with its tea ceremony use in mind. The lip, too, has a part left unfinished and gives the impression that the bowl was made just for fun. The foot, however, is trimmed into a regular circular form, although it is not entirely free from the rigidness of the Kamanokuchi style. On the other hand, the white, opaque straw-ash glaze thickly covering the entire surface has taken on a faint pink tinge due to the humidity of the kiln, while above the foot it is thin and transparent. The contrast of the glaze on the upper and lower parts of the pot gives life to this bowl as a tea ceremony object. It is named "Fugen" (short for Fugen Bosatsu, the Buddhist divinity Samantabhadra) and is accompanied by a box bearing an inscription by the feudal lord Owari Dainagon Mitsutomo.

7. *Teabowl, ash glaze, named "Kokura-yaki." D. 10.2 cm. Early seventeenth century. Tanakamaru Collection.*
Prior to the establishment of a kiln in Agano Village itself, there was another kiln in Kokura, known as Saienba, which was a private kiln built in the grounds of the feudal lord's house (*oniwa-yaki*). Having been built to make wares for the personal enjoyment of Hosokawa Tadaoki, it must

have been a small kiln in which firing to high temperatures was not possible.

This bowl is thought to have been made at the Saienba kiln. It is covered with a coarse wood-ash glaze, which has come out a loquat yellow, quite unlike the loquat color fired in a large kiln. From the color we can tell that the bowl was fired painstakingly over a long period of time. It probably was the prototype of the famous *wari-zanshō* bowl classified as Kokura ware (Plate 5).

8. Goki-*shaped teabowl, rice-straw-ash glaze. D. 11.1 cm. Early seventeenth century.*

The term *goki* originally denoted a lacquered bowl used in Zen temples, and in ceramics the term refers to a series of Korean Koryŏ dynasty thin-walled ceramic bowls with tall, deep sides and tall, spreading feet. This is one of the *goki*-shaped teabowls that have been unearthed in fairly large numbers on the site of the Kamanokuchi kiln. The splayed foot and the area above it are somewhat robust in form, but the coarse, porous body and the matt straw-ash glaze show a pleasant harmony. Though small, the bowl features a neatly finished shape.

9. *Tea ceremony water container with handles, ash glaze over iron oxide. H. 15.5 cm. Early seventeenth century. Tanakamaru Collection.*

This is a water container made at the Kamanokuchi kiln, which was run by Hosokawa Sansai, lord of the fief of Kokura, after he had transferred the headship of his family to his son Tadatoshi in 1605. The factory continued to be active for about thirty years until it moved to Higo Province.

The major products of this factory were tea ceremony objects, which, reflecting the military character of the lord Sansai, tended to show straight-lined forms, more rigid than one usually finds among tea ceremony wares.

This water container has a straight, upright mouth and retains the rough markings of wheel work. The decoration in iron pigment is very abstract and can hardly be called a painting. The handles are merely decorative, and the glaze colors are subdued, so that the entire effect is of well-controlled but unrefined workmanship. It is a typical example of the early period of the Kamanokuchi kiln.

10. *Saké bottle, amber glaze. H. 24.8 cm. Early seventeenth century.*

This bottle was unearthed at the site of the Iwaya Kōrai kiln, which was established at approximately the same time as the Kamanokuchi kiln. While Kamanokuchi was an officially patronized workshop, the Iwaya Kōrai kiln was privately run and shows a free, easy style. Tea caddies, teabowls, and water containers have been unearthed along with numerous utensils for everyday use.

The clay body is fine and is glazed right down to the base with an amber iron glaze. It was fired on a sandy surface. No other wheel-thrown pot of such large dimensions is known to exist.

11. *Square water container, rice-straw-ash and green glazes. H. 19.0 cm. Early seventeenth century. Tanakamaru Collection.*

A rare example of a square water container from Kamanokuchi. It was made by placing a wheel-thrown cylinder into a square mold and pressing it from inside, a technique seen also at Shin-wan in South China. The method of trailing a green glaze over a straw-ash glaze is also traceable to the same source.

It is generally believed that Korean potters were the only foreigners to offer technical guidance at pottery workshops in western Japan after the Bunroku and Keichō wars, but in fact Chinese potters also came over to Japan. A letter by Hosokawa Tadatoshi, thought to have been written in 1624, refers to "two Chinese men from Agano who have arrived here." This jar is material proof of Chinese influence.

12. *Incense stand, black and brown glazes. H. 5.7 cm. Early seventeenth century. Tanakamaru Collection.*

The shape of this incense stand, together with potters' hand marks made when throwing the pot, immediately reveals that this was made at Kamanokuchi. Its foot rim has been cut into a tripod stand. The top two-thirds is glazed black with a wood-ash glaze. The fact that the pot was fired in a primitive type of kiln means that the two glazes have not fused together where they overlap. Yet it is precisely this that has given the piece an accidental but interesting charm.

The inside of the pot is not glazed because it is an incense stand. The base has also been left unglazed in order to expose the rough body of the clay. Although small in size, this is a fine, balanced piece.

13, 14. *Ladle stand, iron brushwork design. H. 15.4 cm. Early seventeenth century. Idemitsu Museum of Art.*

Pieces of this sort have hitherto been regarded as products of Karatsu, but an example almost identical to this in shape and dimensions, though partly damaged, has been unearthed on the site of the Kamanokuchi kiln.

A stand of this kind is used to hold the long-handled bamboo ladle used for pouring hot water from the kettle into the teabowl. This particular piece is typical of the works of the early Kamanokuchi period. It has a tall, thick foot rim, and its belly shows an angular shape instead of the more rounded form. Foot rim and base are amply covered with glaze. The clay contains some iron, and this has caused the wood-ash glaze to fire loquat yellow.

The kilns used at this time were simple climbing kilns made by forming a framework of split bamboo and filling this in with a mixture of pottery clay and silica sand. Their interior walls were rugged, and this meant that the heat was not always even during firing. As a result, the same glaze would frequently change not just on different pots, but on different parts and inside and outside of a single vessel.

The iron brushwork is abstract, making it hard to tell what kind of flowering plant the design represents. Its rigid effect, in good keeping with the shape of the stand, well exhibits the characteristics of the Kamanokuchi kiln.

15. *Rectangular vase, green glaze. H. 31.5 cm. Late nineteenth century. Idemitsu Museum of Art.*

This rectangular pot was made by joining four slabs together. The mouth of the pot was formed separately and applied to the body. The general shape of the vase has been accentuated by the way in which its four vertical corners have been shaped with a modeling tool.

The bluish green glaze is highly crystalized and varied, being characteristic of the bluish green color of the Totoki family. The pot is signed by Totoki Kihachirō Hoshun, the last official potter at Agano Sarayama, and was made by him about the time he became Totoki VIII. This powerful work stands out among wares made in Sarayama during this period.

16. *Tea caddy, mishima style. H. 7.0 cm. Late eighteenth century.*

The term *mishima* refers to a type of Korean ware made during the Yi dynasty, where the pot is slipped and glazed with celadon, typically with some kind of stamped or inlaid decoration. This technique of inlay was probably brought to Agano by the potter Agano Tōshirō III. Tōshirō came from his workshop to teach ceramic techniques to the Agano potters Hoshō, his son Eizō, as well as to Watari Kyūnojō and Yoshida Kitōda.

The *mishima* technique seen here is as yet immature. The unadjusted Agano feldspar used for the glaze has caused a hard surface, giving the pot a sharkskin (*kairagi*) surface effect. Finger markings are also seen remaining in the clay body. This technical immaturity, however, shows a naive, artless charm free from any excessive display of skill.

17. *Flattened ring-shaped bottle, rice-straw-ash glaze. H. 26.5 cm. Late eighteenth century.*

When Lord Hosokawa was assigned to his new fief in Higo Province, the Korean potter Sonkai and his two eldest sons followed him, but his third son, assuming the surname Totoki, stayed in Buzen. Totoki Hoshō, the fifth generation of potters in the Totoki family, is famous for his hand-modeled pieces, and this bottle is by him.

The main body of the pot has been thrown on the wheel before having the mouth and foot rim applied to it. The bottle has been glazed first in amber iron and then with a rice-straw-ash glaze. This is a powerful work full of fresh vitality, made when the potter was in his forties.

18. *Handled dish, green glaze and iron pigment painting. Greatest D. 27.4 cm. Late eighteenth century. Idemitsu Museum of Art.*

During the period of the Agano Sarayama kiln, more decorative techniques were adopted. This dish has a foliate rim with indentations, and the incising and iron brushwork are abstract. Green glaze has come to be used prominently for the first time. The body of the dish is thin, and a patterned handle has replaced the earlier round one. This gives the pot an appearance of lightness and well displays the characteristics of the Sarayama period of Agano pottery.

19. *Rokushō-nagashi* is a form of overglaze effect in which a bluish green glaze (*rokushō*) is applied over transparent glaze; the former runs over the transparent glaze during firing. During the late Sarayama period, pieces of this kind were mass-produced at the Sarayama kiln and were distributed widely throughout the country. This led to the popular belief that the characteristic color of Agano ware is green.

20. Agano *mokume*. The name *mokume*, or *mokuzuri*, meaning "wood grain," derives from the marbled effect produced by kneading red and white clays together.

21. Agano *sansai* is a three-color (*sansai*) glazing effect brought about by trailing yellow and bluish green glazes over a black glaze. This technique is seen on old Takatori ware produced at the Takuma and Sengoku kilns and was introduced to Agano by Takatori potters when they came to work there in the seventeenth century.

22. Agano *zōgan* is a method of inlay whereby a design is incised in the clay and filled with white slip. White slip is also used to fill stamped patterns and to create rough brushwork effects.

23. Agano *sōmen-nagashi* refers to a feldspar glaze that is obtained near the Agano Waterfall and trailed on the body of the ware via a bamboo tube. The thin lines of glaze were seen to resemble a kind of noodle called *sōmen*, hence the name of this glaze trailing method.

24. *Ki-tataki* literally means "yellow paddling" and refers to a technique whereby the surface of the clay body is paddled with a bundle of hemp palm fiber laden with white slip. The roughened surface of the clay is then glazed in amber.

25. *Tamago-de* is a term used to refer to the fine white clay body with a transparent glaze, and derives its "egg-yolk" (*tamago*) name from the color caused by oxidation firing.

26. Agano combing (*kushime*) is a Takatori technique transmitted to Agano and consists of running a toothed bamboo tool across the surface of a pot that has been coated with slip.

TAKATORI

27, 28. *Large jar, rice-straw-ash glaze. H. 22.8 cm. Early seventeenth century. Idemitsu Museum of Art.*

The feudal lord Kuroda Nagamasa ordered one of his vassals, Tezuka Hyōsetsu, to build a pottery kiln at the foot of Mt. Takatori so that pottery ware could be made and fired there. The site of this kiln may be found in what is now known as Eiman-ji Takuma Kamadoko, in Nōgata City.

Takuma ware is characterized by the roughness of its wheel work. Usually, the cord marks when pots have been cut off the wheelhead may be clearly seen, and frequently the wall of the pot above the foot is trimmed away with a knife.

The base of this jar cracked during drying, after it had been thrown. The base was then hollowed out in order to remove the cracked part, and this inevitably created a thick foot rim. Scratches still remain on the inside of the foot. The area around the foot is cut away in a similar bold manner.

Takuma potters made some of the most powerful, impressive Takatori pieces. Their style is totally different from that of Sonkai and his group, who started Agano ware simultaneously in the next valley. Takuma pots feature a thick, short robust foot, and this shape has been noted in the Hoeryŏng area of North Korea. The rice-straw-ash glaze, too, is to be seen on wares from Myŏngch'ŏn, Hoeryŏng, and the Nüchen Manchurians' territory near the Chinese border.

The body is brown, covered with a transparent straw-ash glaze. High humidity in the kiln prevented the temperature from rising very quickly during firing. This meant that the ware had to be fired over a long time, resulting in a smooth surface luster. The jar is large and dynamic and is a notable masterpiece among the rare similar pots of the Takuma kiln.

29. *Deep square food bowls, rice-straw-ash glaze. H. 9.5 cm. Early seventeenth century. Idemitsu Museum of Art.*
These bowls are typical of the Takuma kiln in the way the foot rims have been trimmed and in the effect of straw-ash glaze applied over the ferruginous body. They have fortunately survived in a complete set of five.

30. *Teabowl, ash glaze. D. 12.5 cm. Early seventeenth century.*
This teabowl was made at the Jōbata kiln, an experimental workshop of the Kuroda clan prior to the birth of the name Takatori ware. The site is now an orange orchard, making it impossible to identify the kilns. The clay used for Jōbata products is either ferruginous or sandy clay with low heat resistance, which must have caused the potters plenty of problems during firing.

This bowl is made of sandy clay. Fired at high temperature, it has absorbed the glaze into the body. The foot is known as a *suna-kōdai*, or "sand foot," because of the traces of sand on it. Sand was spread under the foot to prevent the pot from sticking to the pot underneath when they were stacked for firing.

31. *"Shoe-"shaped teabowl, rice-straw-ash glaze. H. 7.9 cm. Early seventeenth century.*
The Takuma kiln also produced objects such as candlesticks and food dishes under the influence of Oribe ware. This teabowl, covered with a thick glaze and having a short foot, is a rare example that has been unearthed. Straw-ash glaze applied over the ferruginous body was reduction fired at a high temperature. The glaze on the mouth has run down to impart a bluish tinge to the ferruginous surface, which blends attractively with the white straw-ash glaze. The effect is characteristic of the Takuma kiln.

32. *Squat water container, ash glaze. H. 8.3 cm. Early seventeenth century. Tanakamaru Collection.*
Potters of the Takatori group who migrated from Takuma to Uchigaiso developed a discernibly different style, which partly resulted from the difference of the pottery clay used at the two kiln sites. Many designs were adopted that reflected the taste of Oribe. One example is this tea ceremony water container, decorated with seemingly random incised lines. The base has been cut by what is known as the *ita-okoshi* method and stands on three stubby cylindrical feet. It is worth mentioning that the base of the pot has been stamped with the Chinese character 王, meaning king.

33. *Jar, rice-straw-ash glaze. H. 17.0 cm. Early seventeenth century.*
Rice-straw-ash white and iron amber are the two major glaze colors of the Takuma kiln. This jar was glazed first with amber and then with a straw-ash glaze, which has taken on a bluish tinge. The exposed sandy body seen on the mouth rim tells that the vessel was fired to a maximum temperature, beyond which the shape would have been destroyed.

This to-the-brink firing, when the kiln is shut down just before the clay loses its shape, brings forth the true beauty of ceramic ware. Should the kiln have been fed with another armful of fuel, the excessive heat would have melted and destroyed the mouth of the pot. The decision as to whether more wood should be thrown into the kiln chamber or not constitutes the point of truth for the potter; it determines whether the resulting pieces are successes or failures.

The mouth of this jar is wide. The interior bottom has five spur marks on it, suggesting that the jar was fired with another pot inside it.

The base shows cutting cord marks and is broad and thinly glazed. During firing it rested on four clay supports, which were covered with rice hulls for easy removal.

The tonality of the glaze shows close similarity to the straw-ash glaze of the Jōbata kiln, and it is this that leads scholars to believe that there is a historical and technical link between the Jōbata and Takuma kilns and that the former was the very first to produce Takatori ware. Numerous shards supporting this conjecture have been unearthed.

34. *Three-legged water container, rice-straw-ash glaze. H. 14.5 cm. Early seventeenth century. Idemitsu Museum of Art.*
This *mizusashi* was made at Uchigaiso using a throwing technique borrowed from the Takuma kiln. The body is made of a relatively ferruginous clay. The iron in the clay has resulted in brown spots, due to reduction firing; and these relieve the monotony of a uniform glaze color.

Three-legged water containers from Shirahatayama of the Enshū Takatori period have combed decoration round the side. They are frequently glazed twice in order to produce interesting surface effects and are more ornate than the simpler Uchigaiso pieces. Three-legged vessels made at the latter kiln were fired with the base supported by clay props so that the feet did not touch any surface. At Shirahatayama, on the other hand, almost all pots, from small tea caddies to large crocks, were fired on doughnut-shaped clay rings, which were placed under the base.

This water container shows a clear distinction between the front (*hi-omote*), where the flames have been in direct contact with the glaze during firing, and back (*hi-ura*). It is a fine piece characteristic of old ceramic wares.

35. *Incense stand, rice-straw-ash glaze. H. 6.5 cm. Early seventeenth century.*

The Uchigaiso kiln appears to have fallen into disuse after Hachizō incurred the displeasure of the feudal lord Kuroda Tadayuki. Hachizō himself went to live in seclusion at Yamada, while some of the other former potters moved to Agano pottery workshops. Others went to Sengoku Tōjin-machi, where this piece was made.

The Sengoku ware has a body of fine, iron clay. Everyday wares are trail-glazed, while more specialized tea ceremony pots are glazed all over.

This incense burner has three horizontal grooves to check the glaze from running down too much. These pleasantly match the flat rim of the mouth. The iron in the clay body has caused the straw-ash glaze to take on a bluish tinge during firing, and this adds all the more to the charm of this vessel, which was excavated from the kiln site.

36. *Square-shouldered tea caddy, amber glaze. H. 8.3 cm. Early seventeenth century. Tanakamaru Collection.*

Takuma kiln tea caddies were made with unrefined clay, and as a result, are somewhat coarse in texture compared with the refined clay used at Uchigaiso. The clay used for this caddy, however, is still a bit on the coarse side and the wall is slightly thick compared with later Shirahatayama tea caddies; still the piece, with its wheel marks remaining, exudes a certain artless beauty that is characteristic of old style pots.

The manner of glazing, too, is unsophisticated. The splash of white glaze on the front side was probably not an intended but an accidental effect. It is a very important specimen of tea caddies fired in the Uchigaiso kiln.

37. *Water container, ash glaze, incised line decoration. H. 18.3 cm. Early seventeenth century.*

This is an Oribe style piece made at the Uchigaiso kiln. It is very masculine in shape, but the linear incisions and the contrived distortion show how the potter hesitated to give full rein to his original idea. This leads me to suspect that there was one group of potters that was good at the Oribe style and another that was not. I felt this strongly while classifying the specimens unearthed on the site of the Uchigaiso kiln.

Due to the amount of iron in the clay body and its low heat resistance, the rim at the base of the pot sticks out at three points. The base has been marked with a cross enclosed in a circle. The glaze is a mixture of wood ash and a small amount of reddish clay, the origin of what is known as the *dōge* glaze. The jar provides valuable material for the study of the history of Takatori ware.

38. *Molded and handled dish, amber glaze. Greatest L. 17.5 cm. Early seventeenth century. Tanakamaru Collection.*

Vessels made at Uchigaiso were not only thrown on the wheel. Imitation of the Oribe style led to other techniques of forming being adopted—for instance, paddling and molding. Various new shapes also appeared, including vessels in the shapes of fans, *musubi-bumi* (emulating a letter folded in a chevron shape), double gourds, and tree leaves.

39, 40. *Lugged water container, ash glaze. H. 15.5 cm. Early seventeenth century.*

This is a water container in Oribe style. It was fashioned by coiling and paddling. The base stood on three feet, but one of these is now missing. The undersurface of the feet shows traces of crushed freshwater mussel (*shijimi*) shell, on which it rested during firing, for the jar was made at a kiln located deep in the mountains of Kyushu. The base has two parallel incised lines, a mark seen only on pieces considered high quality. Five horizontal lines are incised around the sides of the vessel.

The glaze is the prototype of what is now known as the Takamiya glaze, and this makes it a typical example of Oribe-style pottery in Kyushu.

41. *"Shoe-" shaped teabowl, rice-straw-ash and iron glazes. H. 7.0 cm. Early seventeenth century.*

This teabowl, which is of relatively angular form, was made at the Uchigaiso kiln. It has been glazed half-and-half with straw-ash and iron glaze, and the overlapping area shows a beautiful color effect. The sides have simple incised decorations on them. The foot rim is a "split foot" (*wari-kōdai*), with four powerfully cut V-shaped notches, and these show white clay with little iron in it.

Shards of similar "shoe-" shaped teabowls, as well as a few complete pieces of a similar kind, have been unearthed at the Uchigaiso kiln site, suggesting that this kind of pot may have originated there. This bowl is said to have originally been an heirloom of the Sekido family in Owari Province (present Aichi Prefecture).

42, 43. *Wall vase, ash glaze, incised line decoration. H. 21.8 cm. Early seventeenth century. Idemitsu Museum of Art.*

A vase made at Kamano-o, Uchigaiso, in what is now Nōgata City. The Uchigaiso kiln produced the richest variety of pots among old Takatori wares. While wheel-throwing was the only method of forming pottery at Takuma, new methods such as paddling and molding also came into use here. Techniques to the taste of Oribe were freely employed, and incised decorations, combing, and iron oxide brushwork were executed with great realism and impact.

This pot was made by coiling and paddling, the sides boldly flattened. A wavy line decorates the neck; the sides have three horizontal grooves and a lattice pattern that was sharply incised with a metal knife.

Wall vases of the time were fairly large, being nearly 30 cm. high. They had holes made in the clay on opposite sides of the pot to allow the pot to be hung on a nail, and the side that looked better after firing was regarded as the "front" of the pot. This vase bears on the "back" side an incised character 小 (small) within a circle.

The base was distorted because of the paddling of the sides and had to be scraped smooth to make it stable. The two parallel lines on the base are ones found frequently on fine pieces of Oribe style, though it is still not known what they mean.

The variety of styles of Uchigaiso products seems to suggest that there were several groups of potters working

at the kiln. The master potter Hachizō kept them well under his control and led a vigorous period in the history of old Takatori.

44. Tea caddy, Koishiwara ware, named "Yamaji." H. 7.0 cm. End of seventeenth century. Idemitsu Museum of Art.

The main Takatori workshop was moved in 1665 to Tsutsumi in Koishiwara Village. This tea caddy made at Tsutsumi is somewhat different in style from Shirahatayama ones, and was owned and treasured by the father of Mr. Sazō Idemitsu, founder of the Idemitsu Museum of Art. The box containing it bears an inscription naming it "Yamaji" ("mountain lane") by Gyokuei-kun, daughter of the feudal lord and distingushed tea master Matsudaira Fumai.

45. Eared tea caddy, Shirahatayama ware. H. 10.5 cm. Middle seventeenth century. Idemitsu Museum of Art.

Tea caddies from the Shirahatayama kiln, which was active under the guidance of Enshū, came to be called Enshū Takatori. Early Takatori tea caddies used only a single glaze, but when Igarashi Jizaemon introduced Seto techniques, the workshop produced various fine pieces decorated with a second color glaze applied over a ground glaze. This particular pot is a celebrated example of eared tea caddies.

46. Water container, decoration painted by Priest Sengai. H. 15.0 cm. Early nineteenth century. Idemitsu Museum of Art.

The Takatori workshop moved again during the Hōei era (ca. 1705) to what is now Fukuoka City. This water container was made at Higashi Sarayama. Its four sides have been alternately covered with an amber and a transparent glaze, and the transparent-glazed sides have been decorated with iron oxide. This rare piece with its bamboo design was painted by Sengai, a Zen priest of the Shōfuku-ji temple at Hakata and celebrated as a calligrapher and painter.

47. Square-shouldered tea caddy, Shirahatayama ware. H. 6.5 cm. Middle seventeenth century.

Igarashi Jizaemon was employed as an official potter in 1632. He mastered the Seto style and displayed his ability after he began work at Shirahatayama.

This tea caddy reveals a vigorous style in the way the shoulders have been drawn in square to a large mouth and in the profile of the sides, as well as in the glaze runs. This should be seen as one of Jizaemon's representative works. While tea caddies of this kind ordinarily have a cord-cut base, this piece has a carved-out foot rim. The inside of the foot rim shows spiral knife marks.

48. Teabowl, rice-straw-ash glaze. H. 14.0 cm. Early seventeenth century. Yamada City Office.

This bowl was made at Tōjin-dani, Yamada City, where Hachizō and his son were confined after leaving the Uchigaiso kiln. Hachizō had earlier worked in an official capacity at the Kuroda clan's Takuma and Uchigaiso kilns, but at Yamada he worked on his own. It is reasonable to surmise, therefore, that the pots that he fired there are richly imbued with his own personal characteristics.

This bowl is thickly glazed with a straw-ash glaze, which takes on a pink tinge here and there, resulting in an attractive color effect.

49, 50. Teabowl, rice-straw-ash glaze. D. 14.4 cm. Early seventeenth century. Yamada City Office.

This is a relatively large teabowl, which was discovered on top of the bowl in the preceding plate in the tomb of a samurai of the time. The bluish tinge caused by the large amount of iron in the clay body makes the bowl almost indistinguishable from Takuma pieces. Its misleading resemblance to early Takuma ware may well be a result of the fact that potters in both the Takuma and Yamada workshops went through similar hard times and suffering. This, at any rate, is the strong impression I get from looking at these two teabowls.

51. Teabowl, ash glaze. D. 14.6 cm. Middle seventeenth century. Tanakamaru Collection.

This is a teabowl made at Shirahatayama in what is Iizuka City after Hachizō and his family were released from their confinement at Yamada.

The bowl is accompanied by a box bearing an inscription to the effect that it was given to a certain man by the feudal lord Kuroda Mitsuyuki. Traditionally the pot has been attributed to the Korean potter Inoue Shinkurō, but it is completely different in style from that of Shinkurō at Takuma. Judging from the fine clay, the glaze, and the horizontal bands, it would seem almost certainly to be a product of the Shirahatayama kiln. Hachizō was succeeded by his second son, also Shinkurō, in 1644. This was because Hachizō's eldest son was not very healthy. This bowl may possibly be by Shinkurō, before he became Hachizō II.

52. Apple-shaped tea caddy. Agano ware by Kōyō Kumagaya. H. 7.5 cm.

Born at Agano in 1912, Kumagaya was ordered by the military authorities to study pottery in Northeastern China during the war. He has diligently engaged in the study of tea ceremony objects, particularly tea caddies, after the war and has excavated the Kamanokuchi kiln site of old Agano.

53. Eggplant-shaped tea caddy. Takatori ware by Miraku Kamei. H. 6.5 cm.

Born in 1931 at Takatori, Nishi Ward, Fukuoka City, Kamei studied under his grandfather before he succeeded to the name Miraku in 1963, becoming Miraku XIV. Since 1956 his work has won prizes at numerous local and nationwide exhibitions. He has studied the tea ceremony wares of the Enshū Takatori period and afterward and is especially good at Chinese type tea caddies.

54. Square water container with cylindrical lugs, by Hassen Takatori. H. 21.0 cm.

Born in 1934 at Nakano Sarayama, Koishiwara Village, Takatori is the grandson of Sashichi Fukushima, who was later adopted into the Takatori family. His work has won numerous prizes at various exhibitions. He diligently studies the style and techniques of Takatori ware, emulating the wares of Enshū Takatori.

55. Bowl, brown glaze, by Takahisa Watari. Mouth D. 36.0 cm.

Born in 1929, Watari restored the Agano Watari kiln in

1963 and has since worked at this kiln. He does research into iron glazes.

56. *Large bowl, ash glaze, comb markings, by Fujinori Kajiwara. D. 60.0 cm.*
Born in Koishiwara in 1937, Fujinori is the eldest son of Tōsuke Kajiwara and has consistently contributed to folkcraft exhibitions. He exhibits widely and has received numerous awards. He is especially good at producing large pieces made by Koishiwara pottery techniques.

57. *Large dish, ash glaze, flowering grass design. Agano ware by Yasuoki Kumagai. D. 42.0 cm.*
This dish is by the eldest son of Kōyō Kumagai, who was born at Agano in 1940. He graduated from the Kanazawa Art College in 1962. His specialty is large dishes, on which he displays his technique of engraved decoration colored with copper glaze.

58. *Large bowl, carbonized amber glaze, by Jun Kōzuru. D. 51.0 cm.*
Born in 1940, Jun is the second son of Kazan Kōzuru of Agano Sarayama. He studied under Deika Sakata of Hagi ware before working with his father. In 1969 he established his own workshop at Wakamiya-chō in Fukuoka Prefecture. He studies various types of wood-ash glaze.

59. *Bowl, iron glaze, by Nobuhiko Shirakawa. D. 48.5 cm.*
Born in 1921, Nobuhiko studied under Tsunesaburō Shirakawa and was adopted by the Shirakawa family. He pursues the study of iron and straw-ash glazes.

Old Agano and Takatori Kiln Sites

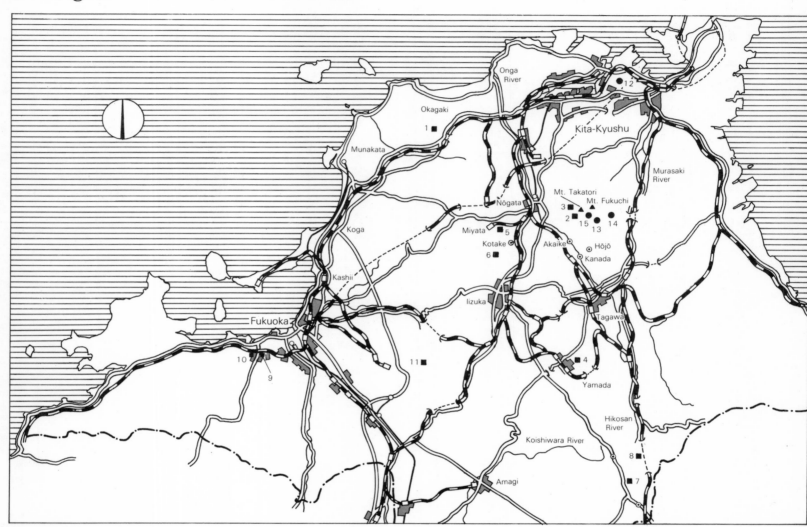

Map labels: Onga River, Okagaki, Munakata, Kita-Kyushu, Murasaki River, Mt. Takatori, Mt. Fukuchi, Nōgata, Koga, Miyata, Kotake, Akaike, Hōjō, Kanada, Kashii, Iizuka, Tagawa, Fukuoka, Yamada, Hikosan River, Koishiwara River, Amagi

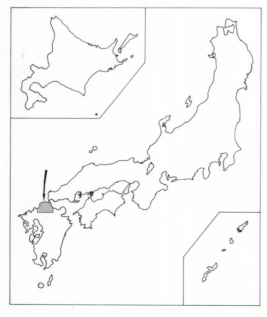

Takatori
1. Jōbata
2. Takuma
3. Uchigaiso
4. Yamada
5. Sengoku
6. Shirahatayama
7. Koishiwara-Tsutsumi
8. Koishiwara-Nakano

9. Higashi-Sarayama
10. Nishi-Sarayama
11. Sue

Agano
12. Saienba
13. Kamanokuchi
14. Iwaya Kōrai
15. Agano Sarayama Hongama

定価2,900円
in Japan

44